MONET

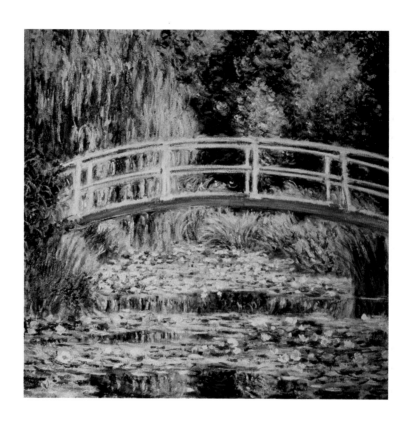

Published by Pulteney Press
1 Riverside Court
St Johns Road
Bath BA2 6PD

ISBN 978-1-906734-67-1

1 3 5 7 9 10 8 6 4 2

© Copyright 2009 Omnipress Limited

Produced by Omnipress Limited, UK

Printed in Indonesia

Images were kindly supplied by Bridgeman Art Library, London.
Picture research: Alex Edouard

Fisherman's Cottage on the Cliffs at Varengeville
1882
Oil on canvas
60.6 x 81.6 cm
Museum of Fine Arts, Boston
Bequest of Anna Perkins Rogers
21.1331
© 2008 Museum of Fine Arts, Boston. All rights reserved.

Rouen Cathedral Façade and Tour d'Albane (Morning Effect)
1894
Oil on canvas
106.1 x 73.9 cm
Museum of Fine Arts, Boston
Tompkins Collection—Arthur Gordon Tompkins Fund
24.6
© 2008 Museum of Fine Arts, Boston. All rights reserved.

La Japonaise (Camille Monet in Japanese Costume)
1876
Oil on canvas
231.8 x 142.3 cm
Museum of Fine Arts, Boston
1951 Purchase Fund
56.147
© 2008 Museum of Fine Arts, Boston. All rights reserved.

Boulevard Saint-Denis, Argenteuil, in Winter
1875
Oil on canvas
60.9 x 81.6 cm
Museum of Fine Arts, Boston
Gift of Richard Saltonstall
1978.633
© 2008 Museum of Fine Arts, Boston. All rights reserved.

MONET

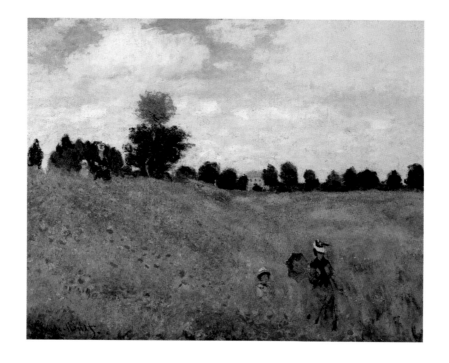

JANICE ANDERSON

PULTENEY
PRESS

Contents

Contents

INTRODUCTION

CLAUDE MONET is generally considered to be the greatest of the Impressionists, that group of young artists working in Paris from the 1860s who were to revolutionise Western art. Not that Monet and his artistic contemporaries thought of themselves as revolutionaries. Rather, they were intent on getting away from the sort of studio-based art promoted and supported by the France's art establishment, the Academy, and out into the open air where, now that oil paints were widely available in flexible tin tubes, paintings could be started and finished out-of-doors.

This ability to complete pictures in the open allowed the artist to concentrate much more on the effect of the changing light and shade on a picture, and to experiment with how best to put his paints on the canvas to achieve the ideal, most realistic effect. One effective way was to use pure colours, unmixed on the palette, and placed on the canvas in short strokes, often so short that they became just dots, or points, of colour (hence the Pointillism of Signac, Seurat and others).

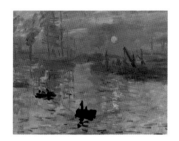

IMPRESSION, SUNRISE
1873. Oil on canvas. Musée Marmottan, Paris, France.

Often, the artist had to work quickly in order to give a true impression of the scene before him. It was just such a painting by Claude Monet, an early morning view from his window of the harbour at Le Havre, that gave Impressionism its name. Monet rather hastily labelled the picture *Impression, Sunrise* (1873) before sending it off to the first exhibition in 1874 of the *Société anonyme des artistes, peintres, sculpteurs, graveurs etc* in which Monet was a major exhibitor. The critics, notably Louis Leroy in an article headed 'Exhibition of the Impressionists' in the magazine *Charivari*, seized on the word 'impression' in the title of Monet's painting as a weapon with which to belabour the work of the artists in the exhibition.

Oscar Claude Monet was born in Paris on 14 November 1840, the second son of a shopkeeper. Within five years of his birth, Monet was taken with his family to Le Havre, where his father hoped to be more successful in business with his brother-in-law, Jacques Lecadre, than he had been in

Paris. Thus, the young Monet grew up on the Normandy coast, with the sounds and scents, the light and shade and the constantly changing winds and weather of the sea and the countryside influencing his senses. There were also the bright clothes and relaxed atmosphere of town likes Deauville, Trouville and Honfleur, holiday magnets for city folk.

It was Eugène Boudin, a local artist much practised in painting the seaside life of the north French coast, who introduced the young Monet to painting *en-plein-air*. While still at school, Monet gained a certain local notoriety with his cleverly drawn caricatures of such local celebrities as his teachers, the mayor and others, which he had learned how to do by studying magazines and which, from about 1857, the year in which his mother died, he sold in Boudin's art materials shop in Le Havre. Now, with Boudin's guidance, he learned to look up from magazines at the real world. In old age, Monet paid tribute to the influence of this 'infinitely kind' man. 'He took it upon himself to teach me. Gradually, my eyes were opened, I really understood Nature, and at the same time I began to love it.'

Monet, never an enthusiastic student, left school before taking his final exams. His mother might have supported his ambition to be a painter, but his father, who had hoped his son would follow him in the family business, was not pleased and refused to give him an allowance, although he did not try to stop his son following his own inclinations. Using the extra pocket money Monet had earned from selling his caricatures, he bought paints and canvases and spent many hours in the open air, often with Boudin, painting. His aunt Sophie Lecadre's country house at Sainte-Adresse gave him a wonderful summertime base from which to sally forth, into the seaside towns, on to the beaches and the cliffs above them and out into the countryside.

Obviously a talented youth, Monet knew that he would have to go to Paris if he wanted to improve his chances of becoming an artist. In 1859, still without an allowance but with some savings from the sale of his caricatures, the 19-year-old Monet left home and went to Paris. Once there, Monet enrolled in the Académie Suisse, a small, private school, founded by a former artists' model. The academy offered no formal teaching or supervision, but had plenty of models – an important consideration for penniless students – and a committed approach to art. Here, Monet was to meet

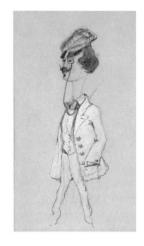

YOUNG MAN WITH A MONOCLE
Pastel and watercolour on paper. 1857. Musée Marmottan, Paris, France.

A CORNER OF THE STUDIO

Oil on canvas. 1885. Musée d'Orsay, Paris, France.

and enjoy fruitful relationships with many young artists, including Camille Pissarro, who was to become a lifelong friend, and Paul Cézanne. As he wrote to Boudin in February 1869, Monet found himself surrounded by landscape artists who were 'real painters'.

Soon, Monet was taking part in *la vie bohème* of Paris, a life which involved much earnest discussion about art in the cafes of the city's artistic quarter. He met many of the rising avant garde artists of the day, including Edouard Manet, Berthe Morisot and others. He also met many members of the Barbizon school of Realist painters who had established themselves in the village of Barbizon in the Forest of Fontainebleau, where they spent their days painting nature in a way that would have been impossible in the studio. One of Monet's paintings from this period in his life, *A Corner of the Studio* (1861), shows that he absorbed well what he learned from the Realists. The picture, while paying homage to the Realists' main subject by including a reddish-brown landscape on the studio wall, gave his subject a sense of immediacy by his careful handling of paint texture and light.

Monet's happy, artistically fruitful life in Paris came to an abrupt end early in 1861

when he was unlucky enough to draw a ticket in the lottery that decided which young Frenchmen should do military service. He chose to join the Chasseurs d'Afrique in Algeria, 'because of its sky'. He found time in the midst of his military duties to do some drawings and watercolours while studying the light and colour of the country, but he contracted typhoid and was invalided home. This was the end of his military service because, after a period of convalescence back at home in Le Havre, his family bought him out. The one condition tied to this generous gesture was that, if Monet returned to the life of an artist in Paris, he should do it in a conventional manner by joining the Ecole des Beaux-Arts.

Monet returned to Paris towards the end of 1862 and entered, not the Beaux-Arts, but the studio of the artist Charles Gleyre. This turned out to be a truly life-defining decision, for it was at Gleyre's studio that Monet met three men whose influence on each other and on the course of art was to be profound. Both Alfred Sisley and Frédéric Bazille came from well-off families, while Pierre-Auguste Renoir's father was a tailor and his mother a dress-maker and his own first experience of art had been as an

apprentice to a porcelain-painter, with lessons at a free drawing school in his spare time.

The four young men, all of them very talented, struck up a close friendship and began doing much of their work together. For a year they worked in Gleyre's studio, though Monet, at least, probably spent more time out of it than in for he did not care for Gleyre's view that antique beauty was a finer quality in a painting than reality. They all left Gleyre's studio at the end of 1863 and, in the years until the outbreak of the Franco-Prussian War in 1870, became extremely talented artists, concentrating on finding and perfecting the techniques that would allow them to paint nature as it existed in reality.

The 1860s was the decade in which Monet's art matured. Often poor and needing to use his paintings to pay the rent, both of his studio and of the apartment he rented – Bazille, in whose large studio Monet often worked, was his greatest source of financial help throughout the decade – he still concentrated on honing his skills and techniques, especially after he achieved his great ambition of having paintings hung in the Salon. He achieved this in 1865, when two marine paintings, *La Pointe de la Hève at Low Tide* and *The Seine Estuary at Honfleur*, were accepted by the Salon. Both depicted Monet's beloved Normandy coast and both found favour with the critics. Much of Monet's work for the rest of the decade was done during the summers and autumns he spent at his family home on the Normandy coast.

His first reaction to being accepted by the Salon was to change his approach to painting; from now on, his Salon ambitions centred on stunning everyone with sheer size. For months, even years, he put all his efforts into huge canvases. First came an enormous, multi-panelled *Déjeuner sur l'herbe*, worked on for months from a base in the Gold Lion inn at Chailly in the Forest of Fontainebleau. Only two panels survive, both of them in the Musée d'Orsay in Paris. Several of Monet's many oil sketches and preliminary paintings for the work survive to give a good idea of what he intended, including the wonderfully spontaneous, light-dappled *Déjeuner sur l'Herbe à Chailly* (1865-66). After this came *Women in The Garden* (1867), another canvas so large that he had to put it in a trench dug in his garden so that he could reach its upper area.

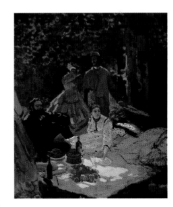

LE DEJEUNER SUR L'HERBE, CHAILLY
Oil on canvas. 1865-1866. Musée D'Orsay, Paris, France.

The *Déjeuner* was never completed, largely because he was ultimately defeated by his inability to get over such a large surface area the same sense of light, achieved with short, single brushstrokes, that he managed in the much smaller (though, at 130 x 181cm, still quite a sizeable picture) *Déjeuner sur l'Herbe à Chailly*. His 1866 Salon offering, painted in a great hurry, was *Woman in a Green Dress* (1866), a very striking painting of his young mistress Camille Doncieux, who had modelled for several of the female figures in *Déjeuner sur l'Herbe* and all of them in *Women in the Garden*. Monet and Camille were now living together, and their first son, Jean was born in 1867.

Woman in a Green Dress was a major success for Monet – and a talking point for critics who began writing articles asking who was the greater artist, Edouard Manet or Claude Monet. The main outcome of such arguing was a practical one: critics began referring to the younger artist as 'Claude Monet', because 'Monet' alone could so easily be read as 'Manet'. Monet's future acceptance by the Salon was not guaranteed, however, and *Women in the Garden* was rejected in 1867, as were Monet's 1868 submissions. Bazille

eventually helped Monet out by buying *Women in the Garden* in instalments.

Life for Monet and his contemporaries took a terrible turn in 1870, with the outbreak of the Franco-Prussian War in July, just a month after Monet and Camille had been married. To avoid being called-up, Monet moved hastily to England, where Camille Pissarro was happily based in south London, leaving Camille and Jean with his family. There were good things about England; he liked the light and the ever-changing skies over London, he was eventually joined by Camille and Jean, and he met an art dealer, Paul Durand-Ruel, who was to have an enormous influence on his later career. For Monet, the greatest tragedy of the Franco-Prussian War was the death of Frédéric Bazille, killed in a minor skirmish with the enemy.

Back in France, by way of Holland, in 1871, Monet settled down to the life of a married artist, renting a house and garden – he always needed to have a garden in which to work and paint – in the riverside town of Argenteuil, just a short railway journey from Paris's Gare St-Lazare, where his friends, especially Renoir, could join him for long, sunny days painting in the garden, in the town and on the river. It was during the

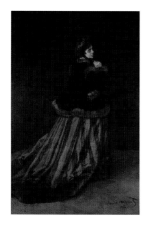

CAMILLE, OR THE WOMAN IN THE GREEN DRESS
Oil on canvas. 1866. Camille Doncieux, Kunsthalle Bremen, Germany.

1870s that Monet, and Impressionism, moved to the forefront of artistic life in France. Paul Durand-Ruel began buying his paintings in quantity, he acquired a patron in the person of department store director, Ernest Hoschedé, he added a 'studio boat' to his possessions so that he could paint the river and riverside scenes from the water, and he and Camille had a second son, Michel, born in 1878. But Camille did not recover strength after the birth and died in September 1879, at the small house in Vétheuil to which the family had recently moved.

Fed up with constant Salon rejections, a group of artists, with many core Impressionists at its centre, decided to mount their own exhibitions. The first of eight exhibitions held by the Impressionists took place in a former studio of the artist and photographer Nadar in Paris in April–May 1874. Among the artists exhibiting with the *Société anonyme des artistes etc* were Monet, Cézanne, Berthe Morisot, Pissaro, Renoir, Rouart and Sisley. The show was a fiasco and the *Société anonyme* was dissolved at the end of the year. After this, the artists called their exhibitions 'Exposition de peinture', Monet including 18 works in the second exhibition in 1876 but

none in the last one, in 1886. Over all, 118 works by Monet, including 55 'on loan' from his dealers, were shown at the Impressionists' exhibitions.

By the time of the last Impressionist exhibition, Monet was an established and increasingly financially secure artist, whose work was shown mainly at solo exhibitions, an exception being the highly successful joint exhibition of the work of Monet and the sculptor Auguste Rodin held by the dealer Georges Petit in Paris in 1889. Paul Durand-Ruel, who mounted several shows of Monet's work, also exhibited works by Monet in the gallery he opened in New York in 1887.

The 1880s were fruitful and very busy years for Monet, his standing as an artist being recognised in 1888 by the offer of the Cross of the Legion of Honour, which he refused. His family, greatly enlarged by the entry into it of Alice Hoschedé, estranged wife of Ernest Hoschedé, and her six children, became the centre of his domestic life which, from 1883, was itself centred on a house set in its own large garden at Giverny, in the valley of the Seine. From here, he sallied forth on painting expeditions to the south of France (the first one, in 1883, with Renoir, included a visit to Cézanne), to the

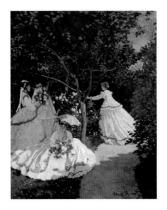

WOMEN IN THE GARDEN
Oil on canvas. 1867. Musée d'Orsay, Paris, France.

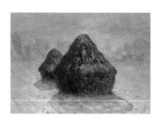

HAYSTACKS, SNOW EFFECT
Oil on canvas. 1891. National Gallery of Scotland, Edinburgh.

north coast of Italy, Holland, England and, many times, to his favourite Normandy and Brittany coasts. Always, whatever the season, he was seeking extremes of light to capture on canvas.

Monet began his famous 'series' paintings in 1890, the year in which he bought the house at Giverny and began expanding its garden. In his series paintings, Monet was intent on exploring in an even more precise way than in his landscapes light, atmosphere, and time: he would even note on the back of his canvases the hour of the day during which he had worked on them. His first series had as its subject the haystacks that farmers left in the fields around Giverny in summer, and which he had already included in several landscapes. Now his haystacks took on almost abstract forms affected by variations in the atmosphere as he painted them at all times of day and in every season. Durand-Ruel's exhibition of these in 1891 was a big success.

The Haystacks series was followed by his beautiful series of studies of the poplars that grew along the River Epte near his Giverny home and which he had begun in 1890. After this series came his monumental *Rouen Cathedral* series, which he worked on in two extended campaigns in 1892 and 1893,

setting up his painting materials in an upper room in a building opposite the cathedral's West front. Twenty of Monet's Rouen Cathedral paintings, all dated 1894 and all the result of hours spent in his studio after the initial painting in Rouen, building up the stones of the cathedral in thick layers of impasto, were included in an exhibition of his work at Durand-Ruel's gallery in May 1895. After this came the wonderfully light-filled paintings of his *Mornings on the Seine* series, for many of which he got up before dawn in order to have his easel set up and his palette ready at his chosen place at the right time.

In 1890, Monet had bought the Giverny property he had been renting since 1883. From now on, apart from several trips abroad, notably several times to London at the turn of the century and once to Venice in 1908, Giverny was the main inspiration for Monet's art. When Ernest Hoschedé died in 1892, Monet and Alice were married, and her children, for many years the models for the figures in some of his finest paintings, became his step-children. Now Giverny, whose land area he extended by buying more land on the other side of the railway line and road that ran near the main house and garden. In this new area he built a

Japanese bridge over the pond in 1895, beginning soon afterwards on what was virtually another series, this time of the lily pond with the Japanese bridge over it.

When he later extended the lily pond, it and the water lilies planted in it became the main focus of his work. His first series of water lily paintings, begun in 1899, took until about 1907 to be completed to his satisfaction. By now, his sight was beginning to deteriorate, although not enough to prevent him painting some gloriously light-filled pictures of Venice, which were shown to great acclaim in the Bernheim-Jeune Gallery in Paris in 1912, four years after his visit to the city.

The length of time between the visit to Venice and the first public showing of his paintings was another sign of how depressed and full of despair Monet's failing sight made him. It needed much persuasion on the part of Monet's friend, the politician Georges Clemenceau, to induce him to make a gift of a series of his water lily paintings to the nation. The start of the First World War in 1914 – a war which was soon to bring Giverny alarmingly close to the Front Line – meant that it was not until 1918 that Monet gave eight water lily paintings to the nation, the gift being made to mark the Armistice in November 1918.

By this time, Monet had had another large-scale idea, one that was much greater than his *Déjeuner sur l'herbe* scheme of half a century before. In 1915, despite the problems with building materials because of the War, he had had a third, very large studio built at Giverny. Here he worked on a project for a series of enormous, mural-sized 'decorations', the subject of which was his water lily pond. *The Nymphéas*, or *Water Lilies*, decorations, many of which came to be housed in the purpose-built Orangerie in Paris, were the culmination of Claude Monet's life work.

Two cataract operations in 1923 restoring his sight, Claude Monet was able to go on working vigorously at Giverny until the end of his long life. He was 86 when he died at Giverny on 6 December 1926.

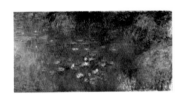

WATERLILIES: MORNING
Oil on canvas. 1914–18. Musée de l'Orangerie, Paris, France.

Plate 1

YOUNG MAN WITH A MONOCLE
Pastel and watercolour on paper. 1857.
Musée Marmottan, Paris, France. 25 x 16 cm.

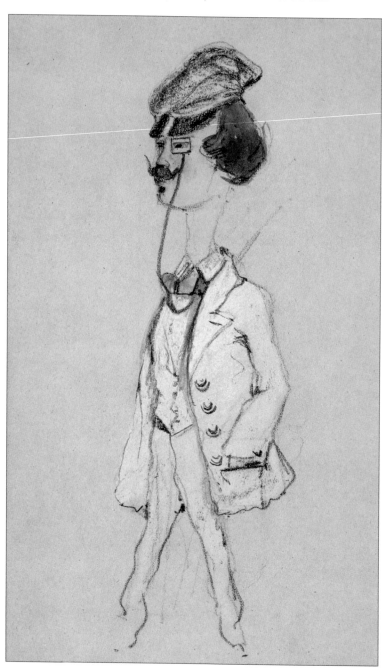

STILL LIFE WITH BOTTLES

Oil on canvas. 1859. Private collection.
41 x 60 cm.

Plate 2

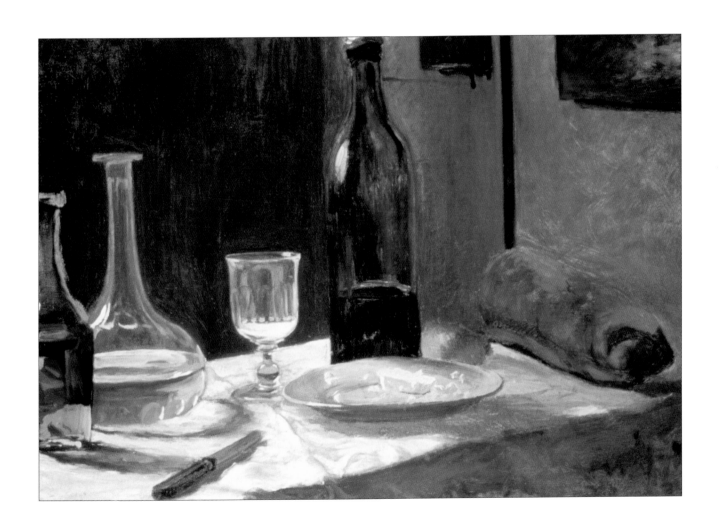

Plate 3

PETIT PANTHEON THÉÂTRAL

Pencil on paper. 1860. Musée Marmottan, Paris, France.
34 x 48 cm.

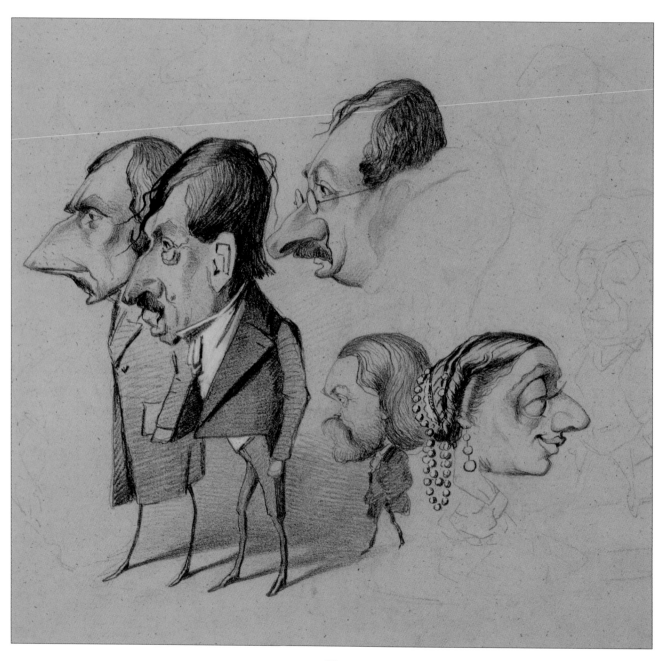

Plate 4

RUE DE LA BAVOLLE, HONFLEUR

Oil on canvas. 1864. Kunsthalle, Mannheim, Germany. 55.9 x 61 cm.

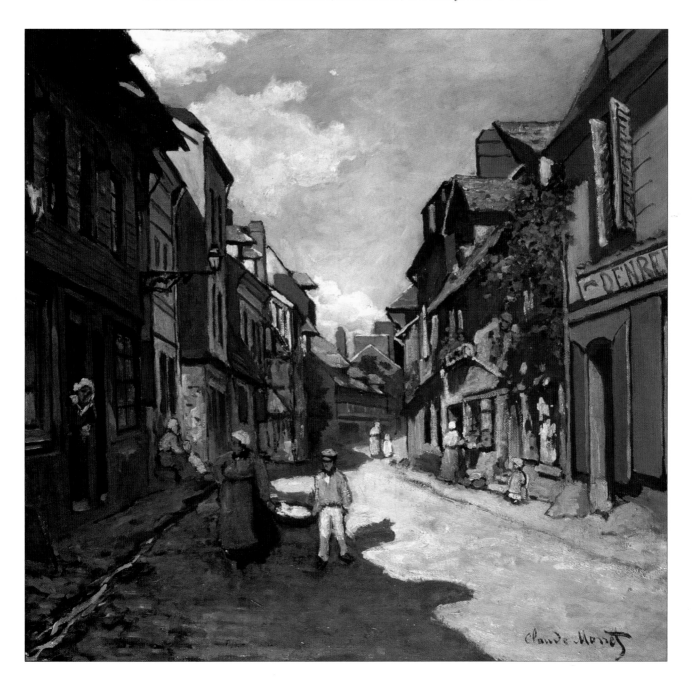

Plate 5

THE ROAD TO BAS-BREAU, FONTAINEBLEAU
(LE PAVE DE CHAILLY)

Oil on canvas. c.1865. Musée d'Orsay, Paris, France.
43.5 x 59 cm.

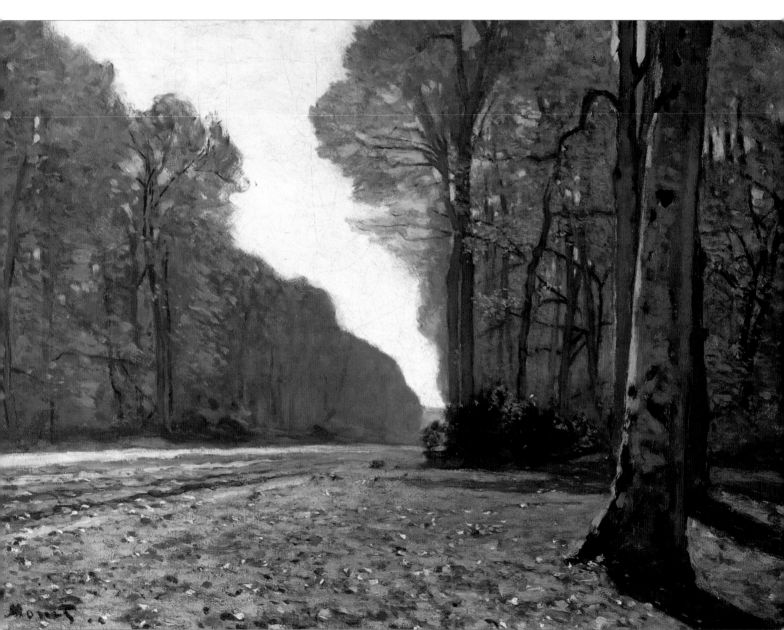

Plate 6

Oil on canvas. 1865. Pushkin Museum, Moscow, Russia.
130 x 181 cm.

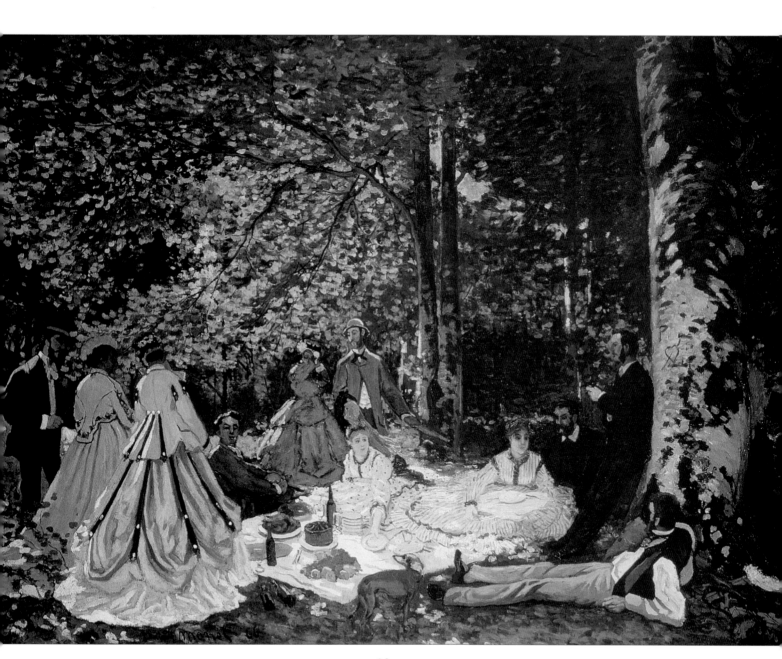

Plate 7

CAMILLE, OR THE WOMAN IN THE GREEN DRESS

Oil on canvas. 1866. Kunsthalle, Bremen, Germany. 79 x 51 cm.

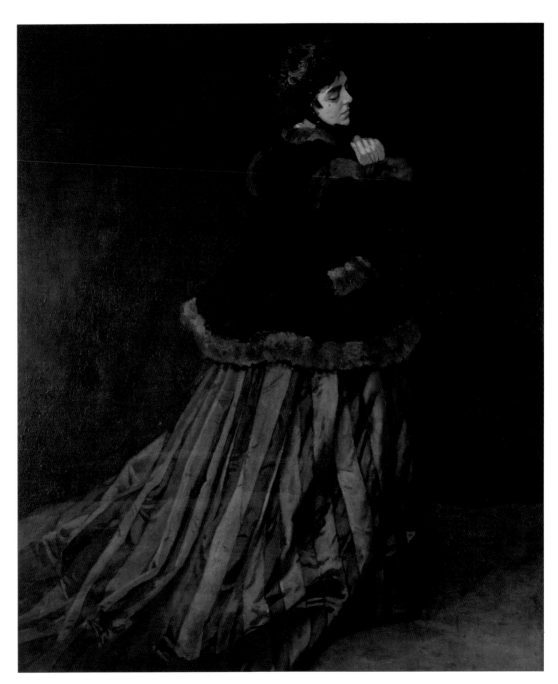

QUAI DU LOUVRE, PARIS

Plate 8

Oil on canvas. 1866–7. Haags Gemeentemusuem, The Hague, Netherlands.
65 x 93 cm.

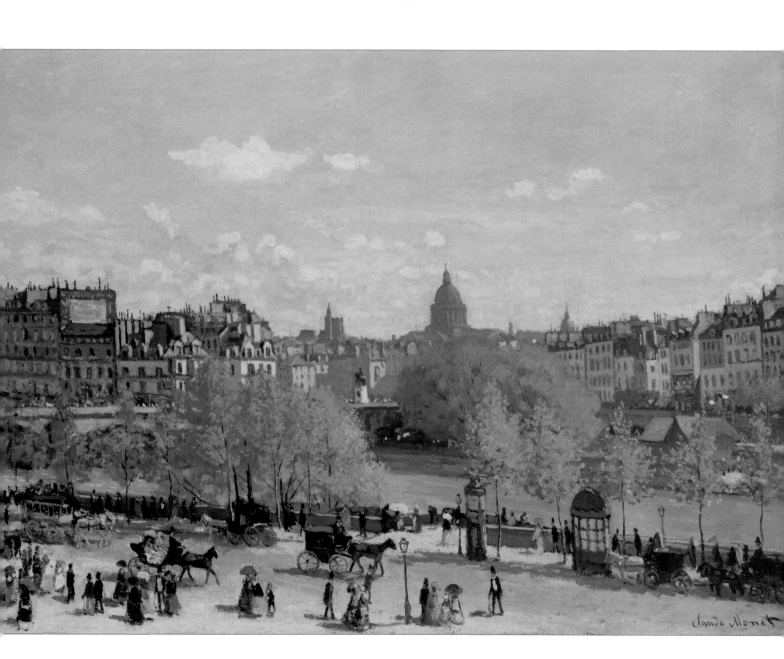

Plate 9

WOMEN IN THE GARDEN

Oil on canvas. 1867. Musée d'Orsay, Paris, France. 255 x 205 cm

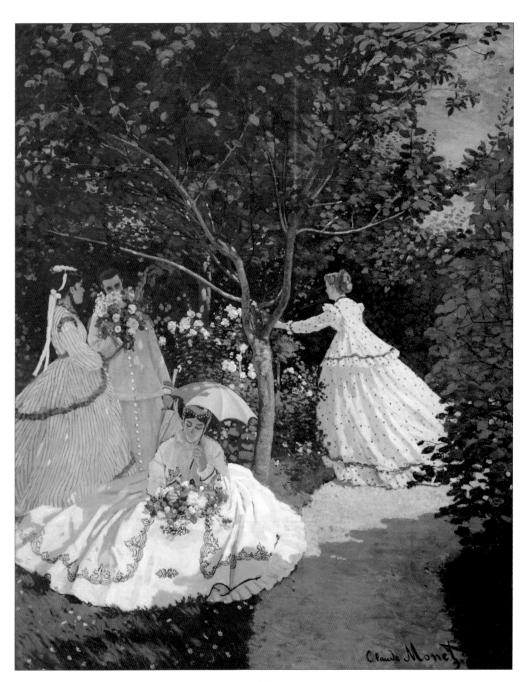

Oil on canvas. 1867. Metropolitan Museum of Art, New York, USA.
98 x 130 cm.

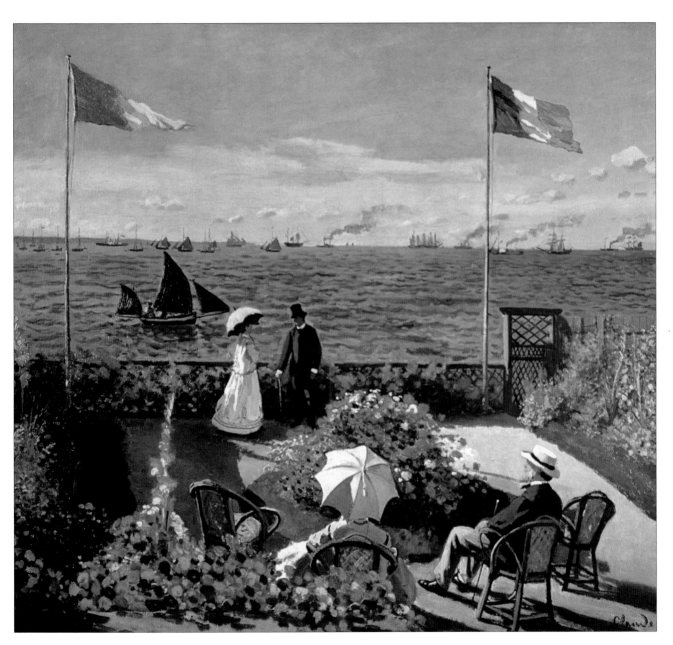

Plate II

THE BEACH AT SAINTE-ADRESSE

Oil on canvas. 1867. Art Institute of Chicago, IL, USA.
75 x 102 cm.

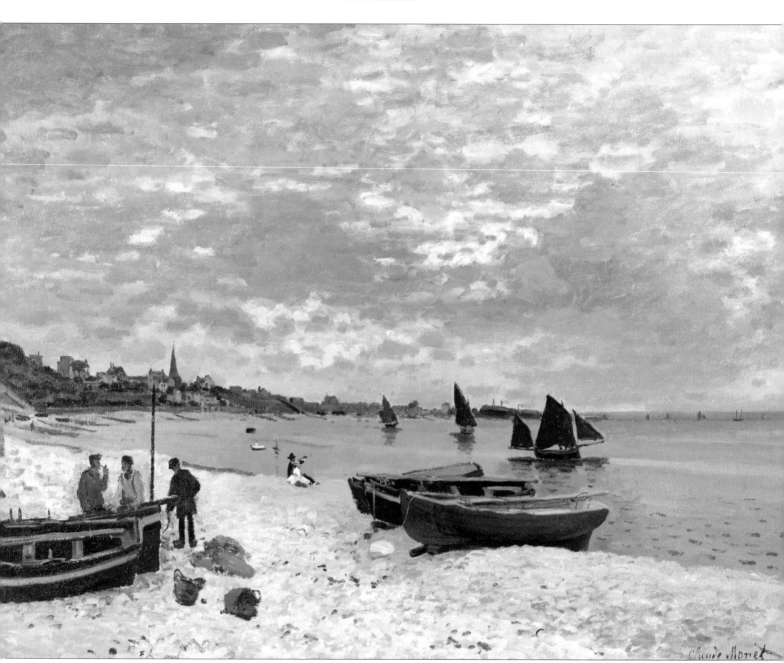

Portrait of Madame Louis Joachim Gaudibert

Plate 12

Oil on canvas. 1868. Musée d'Orsay, Paris, France.
217 x 138.5 cm.

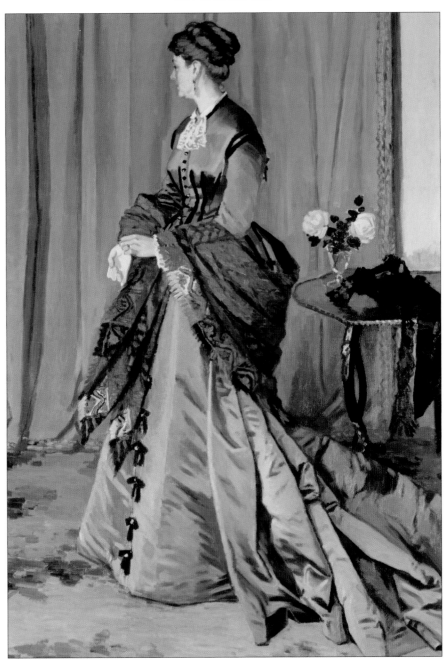

Plate 13

ROUGH SEA AT ETRETAT

Oil on canvas. 1868–69. Musée d'Orsay, Paris, France.
66 x 131 cm.

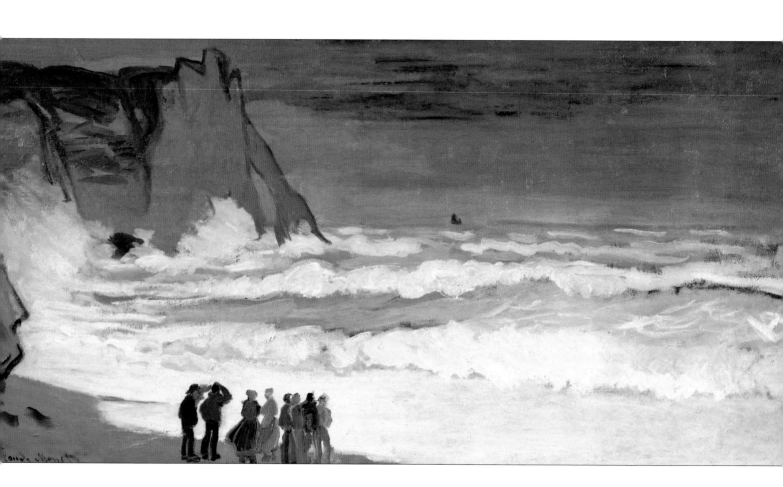

Plate 14

BATHERS AT LA GRENOUILLÈRE

Oil on canvas. 1869. National Gallery, London, UK.
73 x 92 cm.

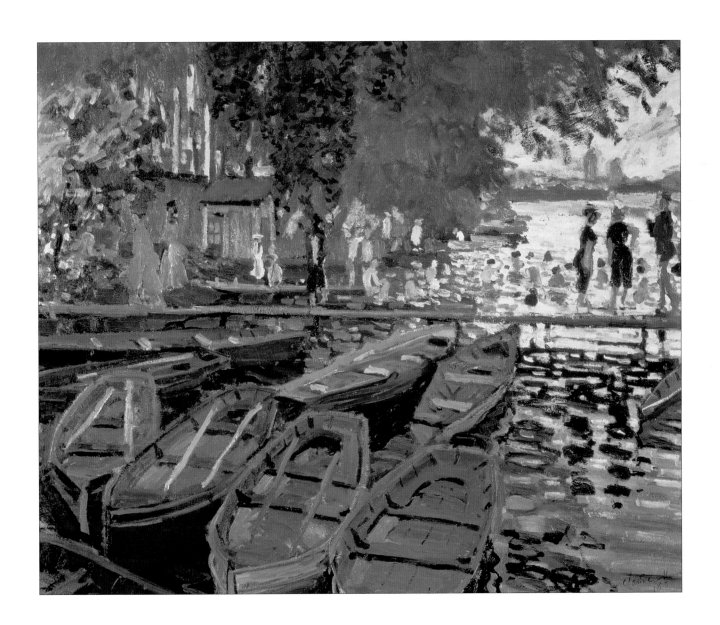

Plate 15

THE MAGPIE

Oil on canvas. 1869. Musée d'Orsay, Paris, France.
89 x 130 cm.

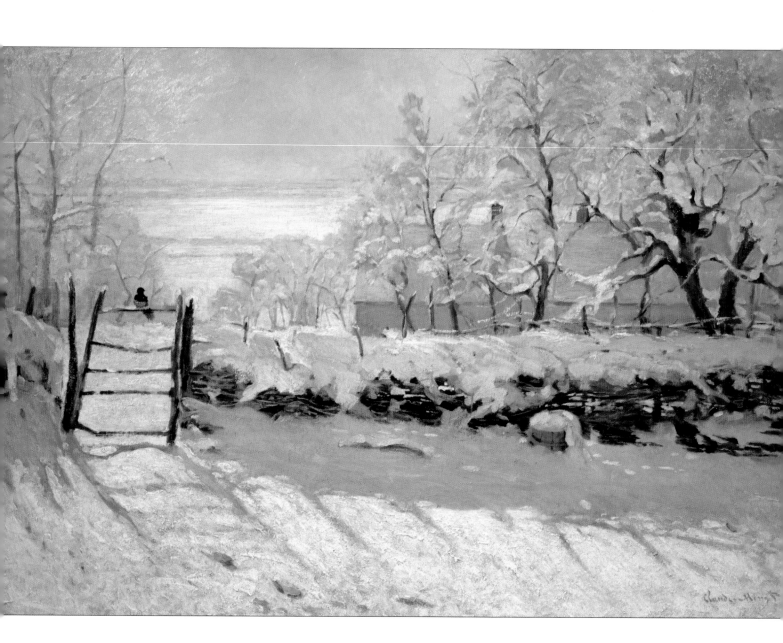

RED MULLET

Plate 16

Oil on canvas. c.1870. Fogg Art Museum, Harvard University
Art Museums, USA.
31 x 46 cm.

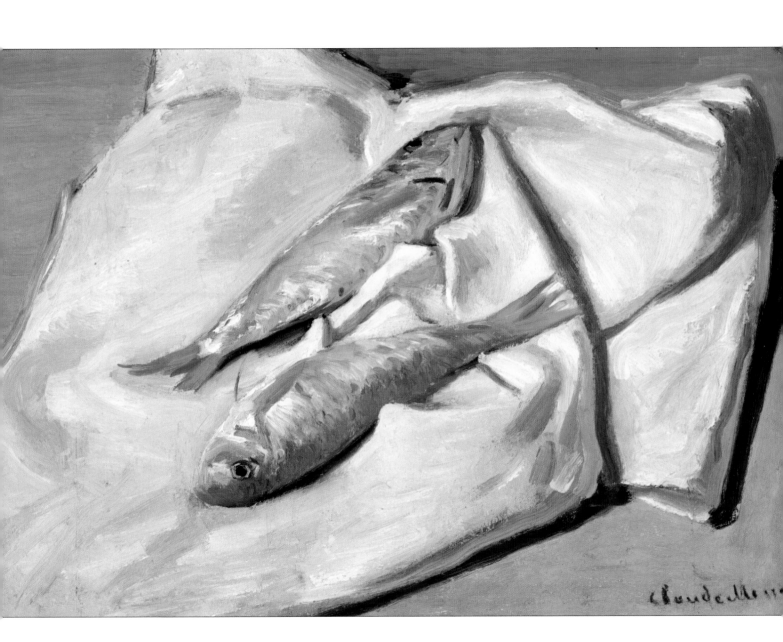

Plate 17

THE RED CAPE (MADAME MONET)

Oil on canvas. c.1870. Cleveland Museum of Art, OH, USA.
100 x 80 cm.

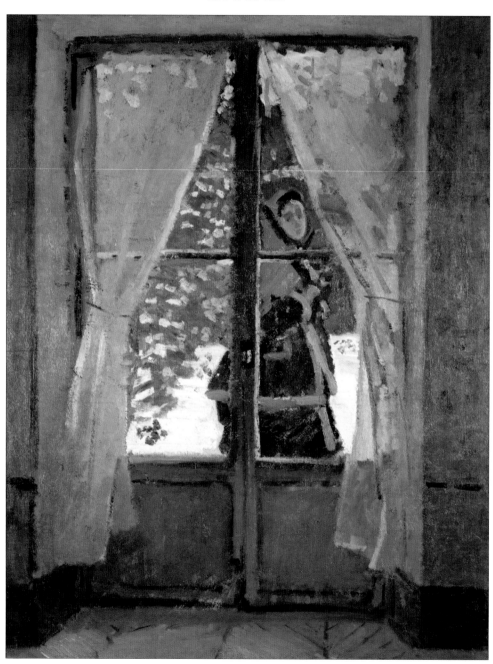

Plate *18*

THE BEACH AT TROUVILLE

Oil on canvas. 1870. National Gallery, London, UK.
37.5 x 45.5 cm.

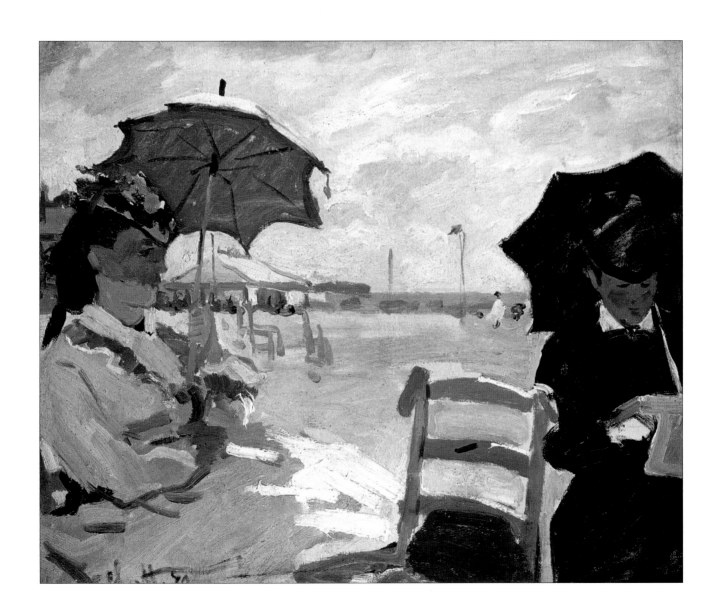

Plate 19

THE JETTY AT LE HAVRE, BAD WEATHER

Oil on canvas. 1870. Private collection.
50 x 60 cm.

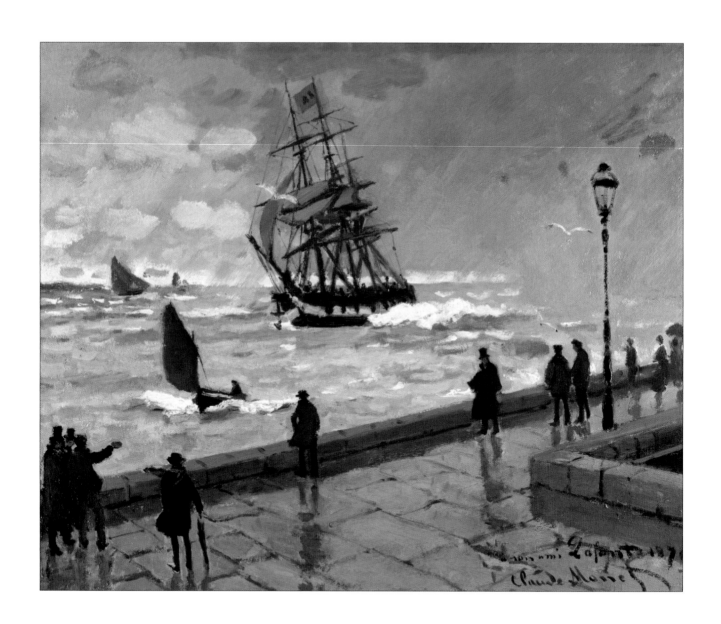

HYDE PARK

Oil on canvas. 1871. Museum of Art, Rhode Island School of Design, USA.

Plate 20

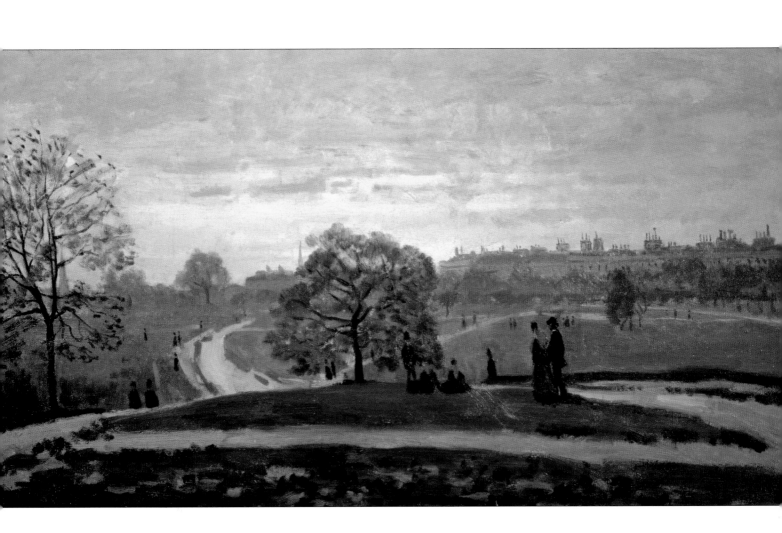

Plate 21

THE THAMES BELOW WESTMINSTER

Oil on canvas. 1871. National Gallery, London, UK.
47 x 72.5 cm.

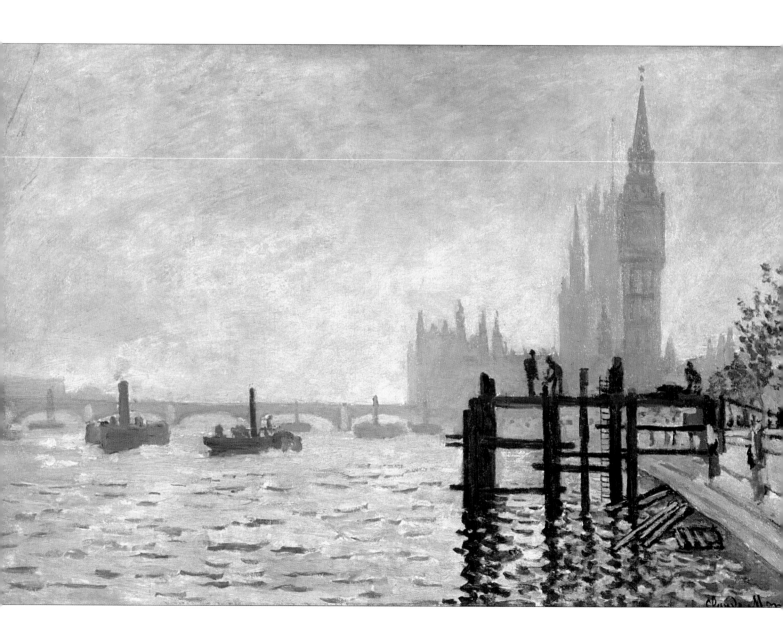

Plate 22

A WINDMILL NEAR ZAANDAM

Oil on canvas. 1871. Ashmolean Museum, University of Oxford, UK.
43 x 73 cm.

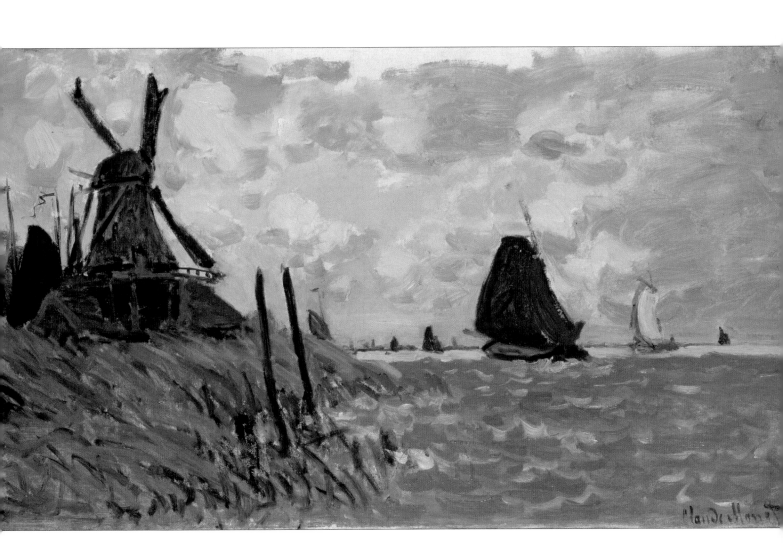

Plate 23

ZAANDAM (HOLLAND)

Oil on canvas. 1871. Musée d'Orsay, Paris, France.

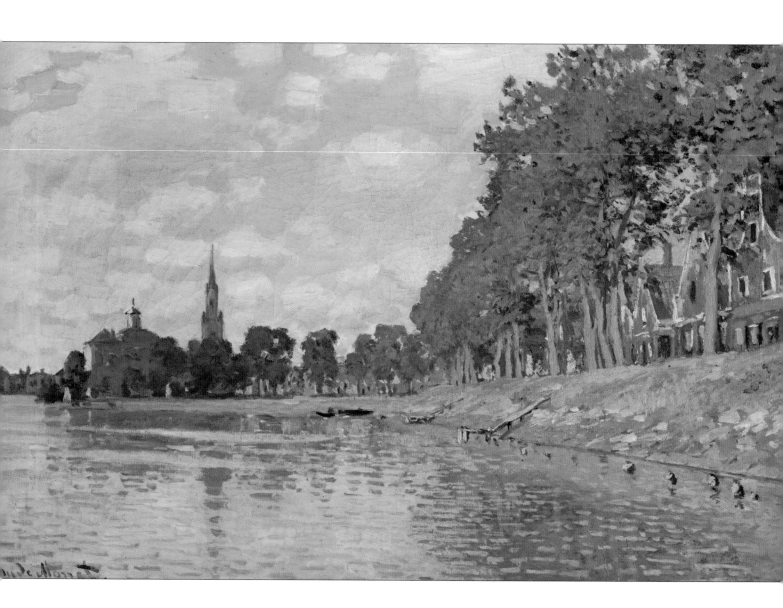

IMPRESSION: SUNRISE, LE HAVRE

Plate 24

Oil on canvas. 1872. Musée Marmottan, Paris, France.
48 x 63 cm.

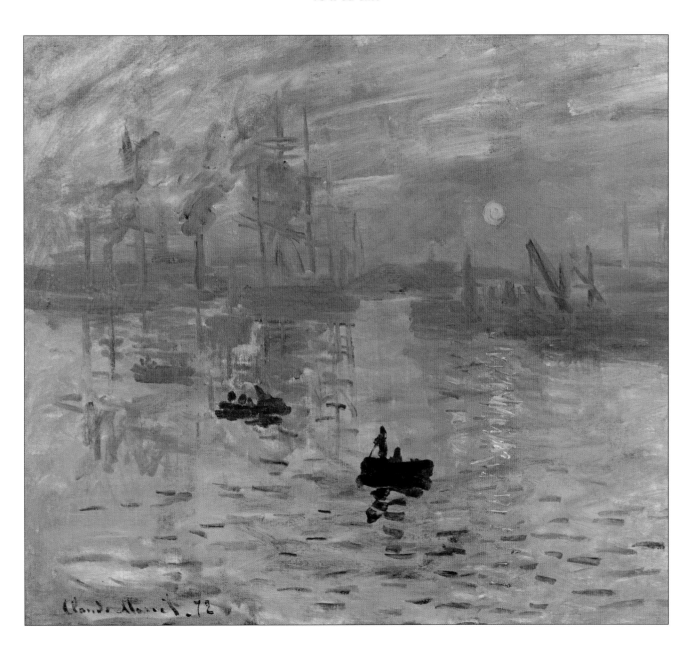

Plate 25

ARGENTEUIL, LATE AFTERNOON

Oil on canvas. 1872. Private collection.
60 x 81 cm.

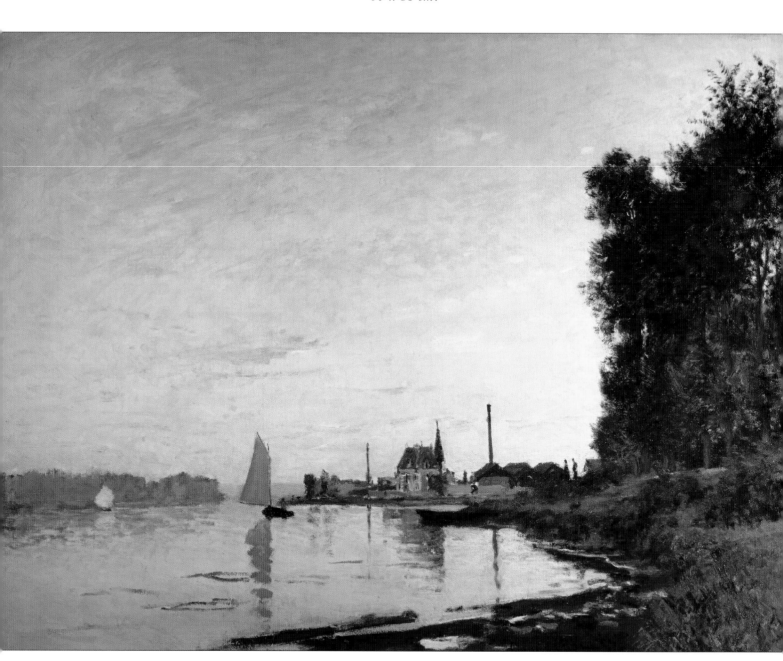

Oil on canvas. 1872. Musée d'Orsay, Paris, France.
60 x 80.5 cm.

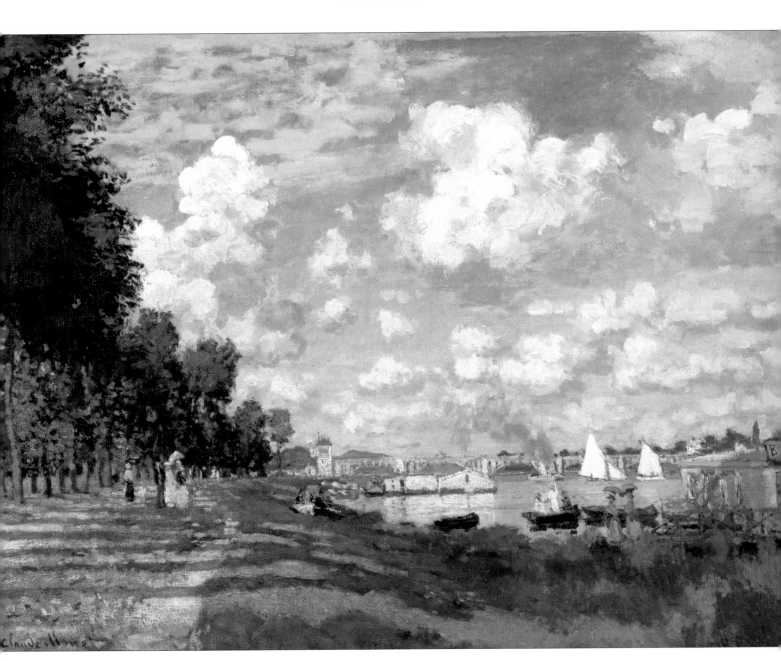

Plate 27

REGATTA AT ARGENTEUIL

Oil on canvas. 1872. Musée d'Orsay, Paris.
48 x 75 cm.

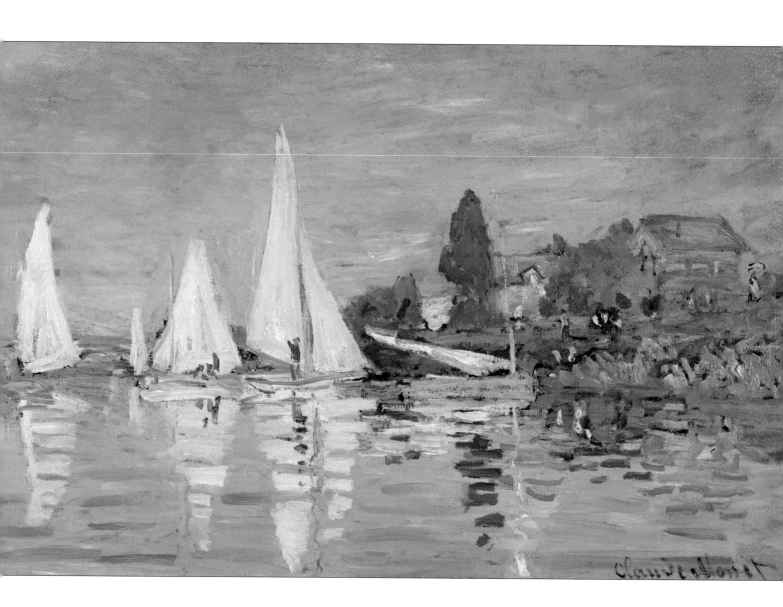

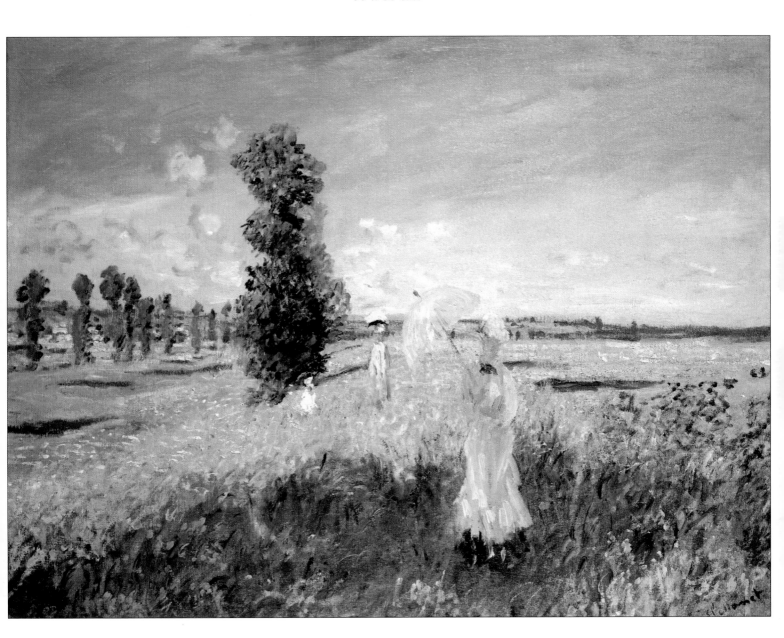

Plate 29

ARGENTEUIL

Oil on canvas. 1872. Musée d'Orsay, Paris, France.
50 x 65 cm.

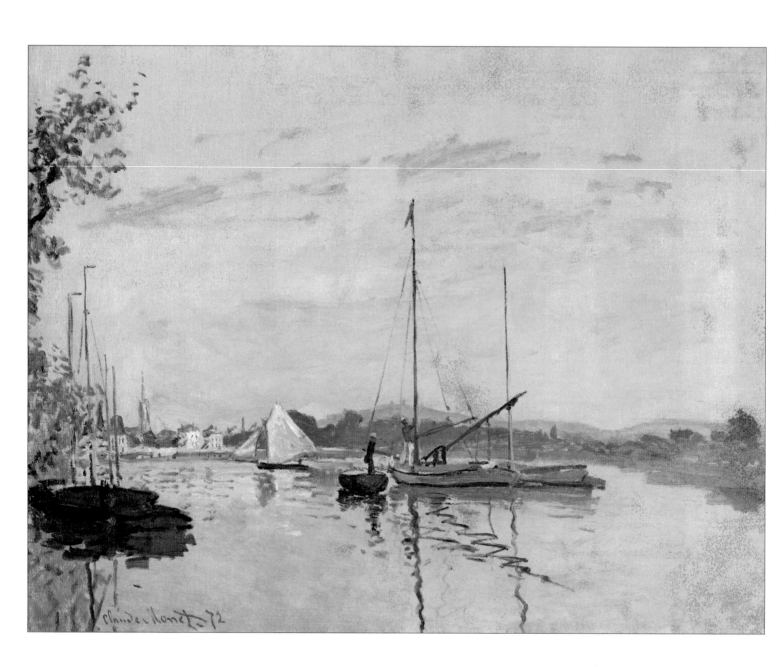

Oil on fabric. c.1872. Walters Art Museum, Baltimore, USA.
50 x 65.5 cm.

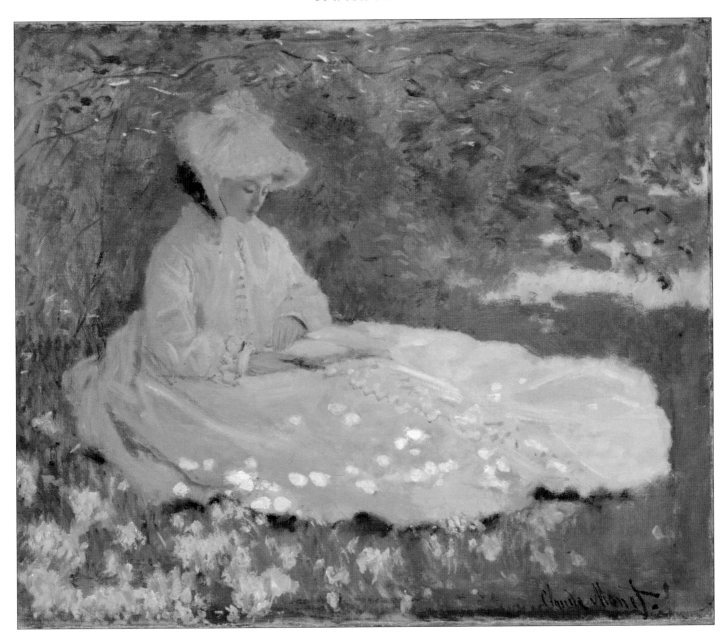

Plate 31

THE LUNCHEON: MONET'S GARDEN AT ARGENTEUIL

Oil on canvas. c.1873. Musée d'Orsay, Paris, France.
160 x 201 cm.

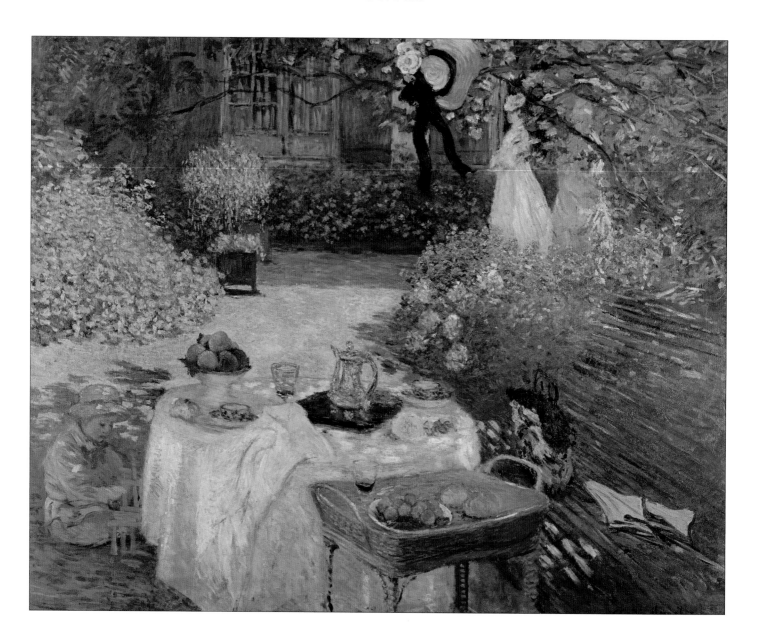

WILD POPPIES, NEAR ARGENTEUIL

Plate 32

Oil on canvas. 1873. Musée d'Orsay, Paris, France.
50 x 65 cm.

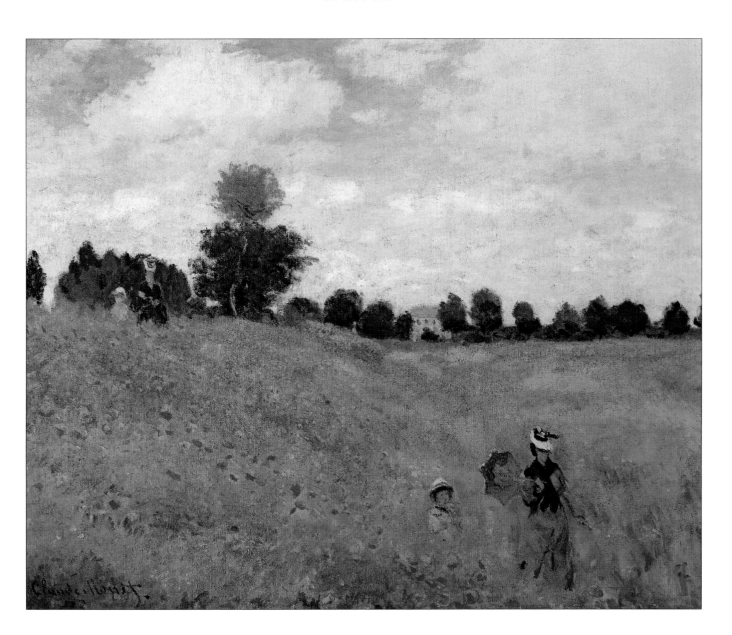

Plate 33 AUTUMN EFFECT AT ARGENTEUIL

Oil on canvas. 1873. Samuel Courtauld Trust, Courtauld Institute Galleries, London.
55 x 74.5 cm.

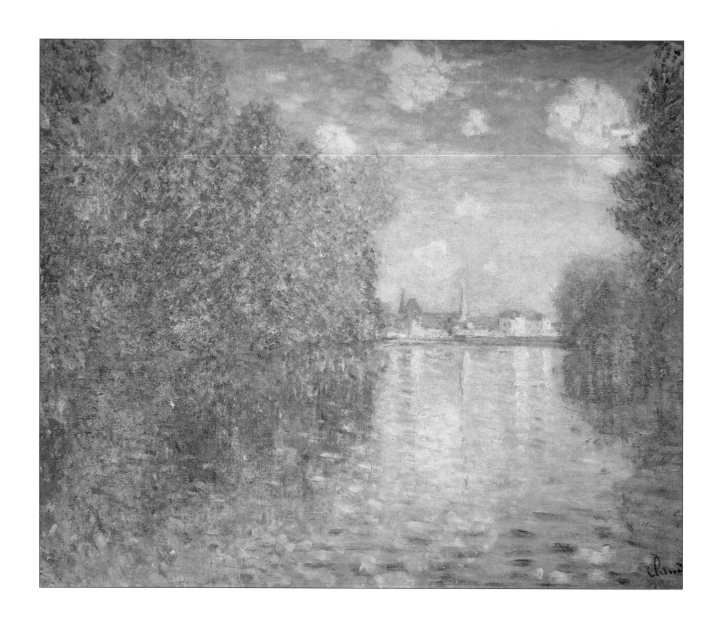

BOULEVARD DES CAPUCINES

Oil on canvas. 1873. Pushkin Museum, Moscow, Russia.
61 x 80 cm.

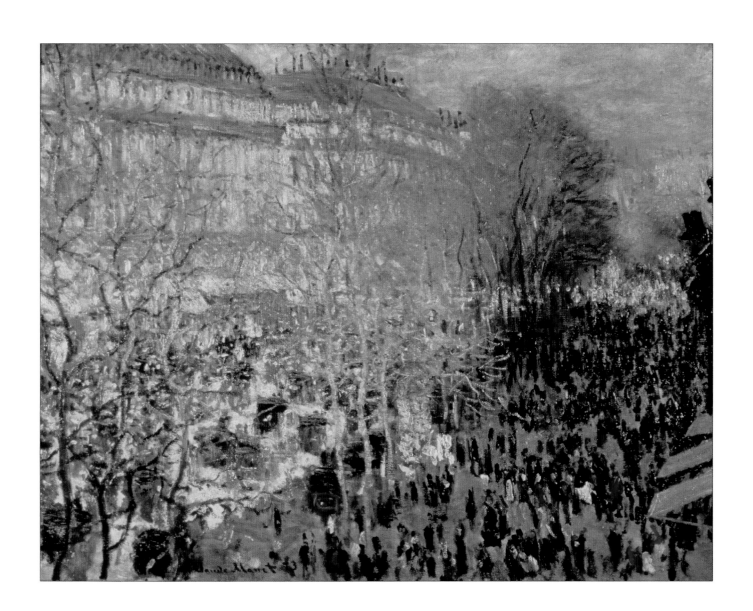

Plate 35

THE BRIDGE AT ARGENTEUIL

Oil on canvas. 1874. Musée d'Orsay, Paris, France.
60.5 x 80 cm.

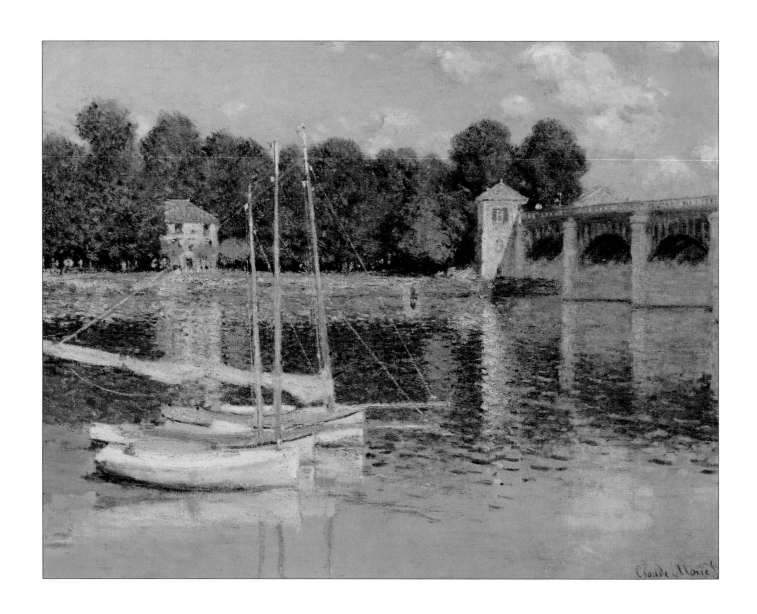

THE BOATS, OR REGATTA AT ARGENTEUIL

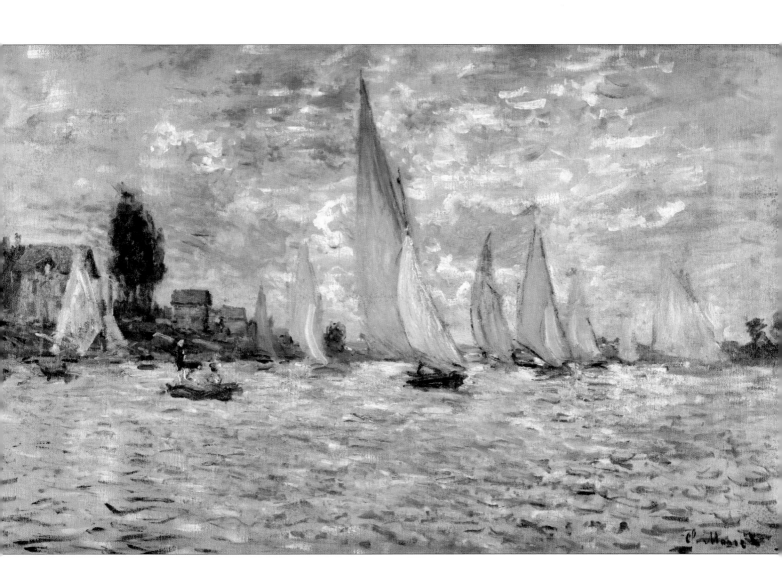

Oil on canvas. 1874. Musée d'Orsay, Paris, France.
60 x 100 cm.

Plate 36

Plate 37

SNOW EFFECT

Oil on canvas. c.1874. Kunsthalle, Basel, Switzerland.
81 x 61 cm.

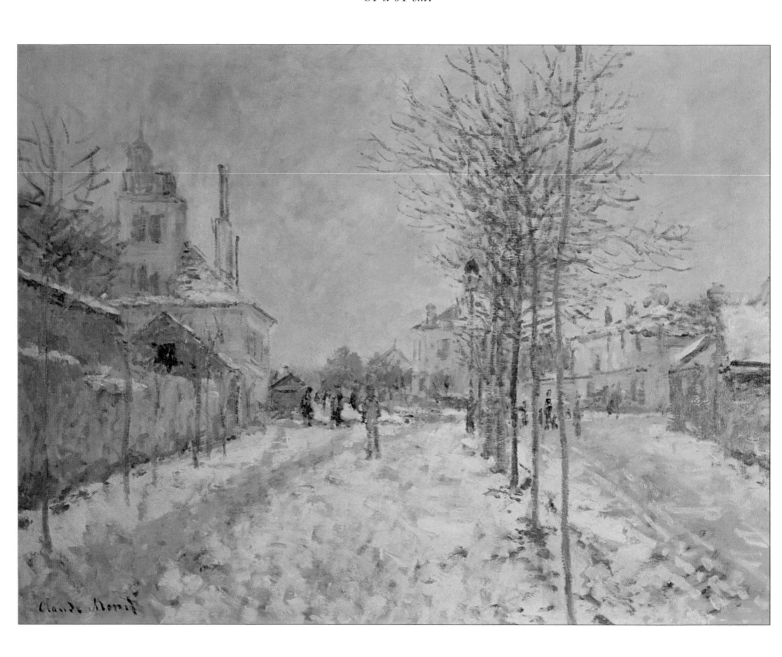

BOULEVARD SAINT–DENIS, ARGENTEUIL, IN WINTER

Oil on canvas. 1875. Museum of Fine Arts, Boston, USA.
61 x 81.5 cm.

Plate 38

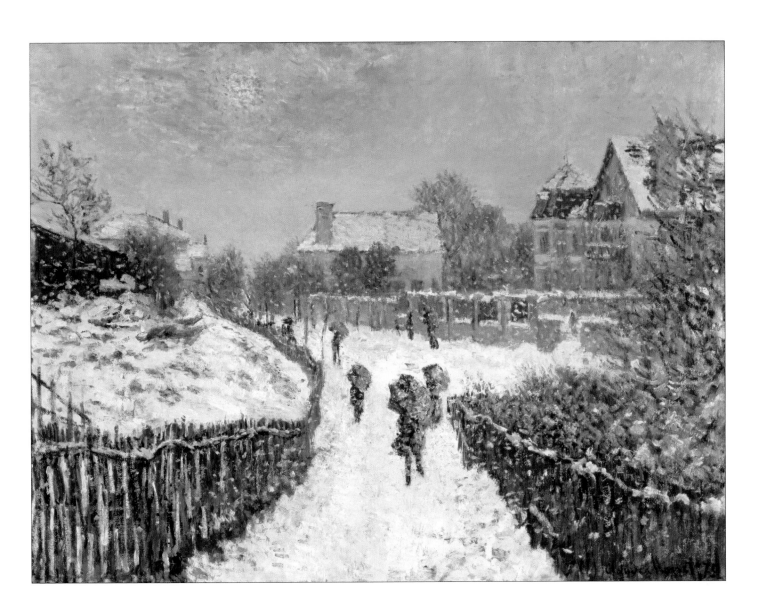

Plate 39

THE COAL WORKERS

Oil on canvas. 1875. Musée d'Orsay, Paris, France.
55 x 66 cm.

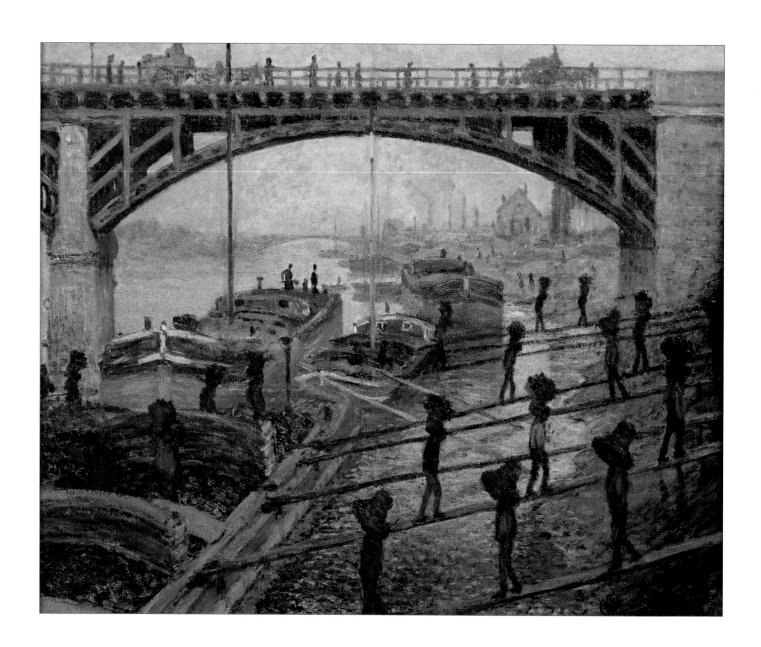

LA JAPONAISE (CAMILLE MONET IN JAPANESE COSTUME) *Plate 40*

Oil on canvas. 1876. Museum of Fine Arts, Boston, USA. 232 x 142 cm.

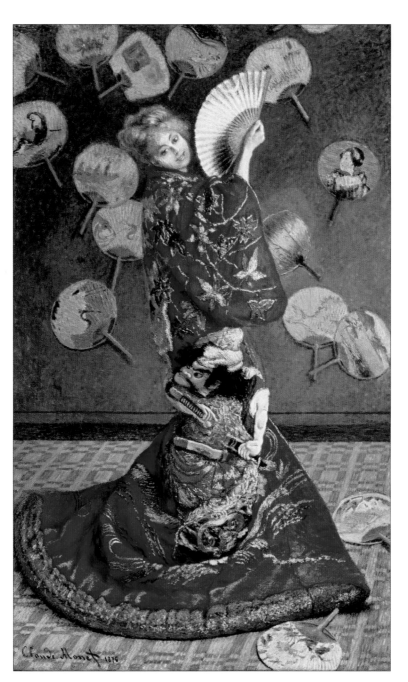

Plate *41*

GLADIOLI

Oil on canvas. c.1876. The Detroit Institute of Arts, USA.
56 x 82.5 cm.

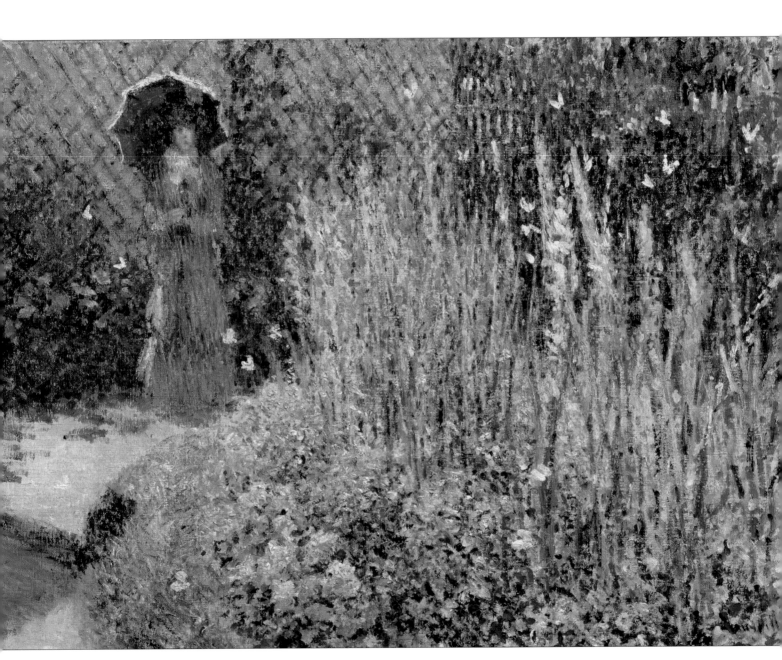

THE BOAT STUDIO

Plate 42

Oil on canvas. 1876. The Barnes Foundation, Merion, Pennsylvania, USA.
72 x 60 cm.

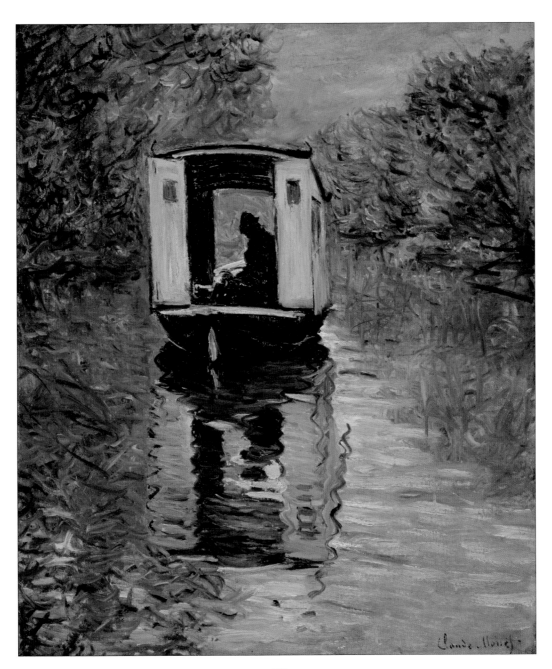

Plate *43*

THE PONT DE L'EUROPE, GARE ST-LAZARE

Oil on canvas. 1877. Musée Marmottan, Paris, France.
64 x 81 cm

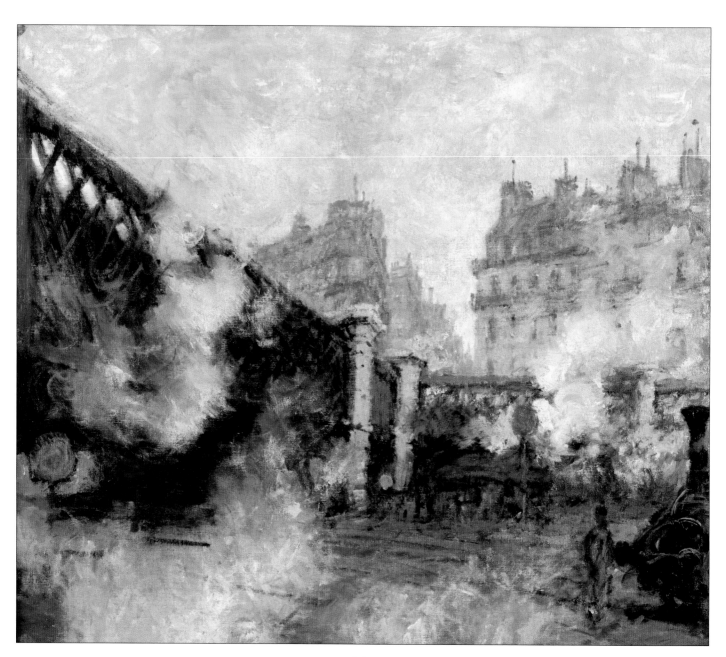

THE GARE ST LAZARE

Plate 44

Oil on canvas. 1877. Musée d'Orsay, Paris, France.
54 x 73.5 cm.

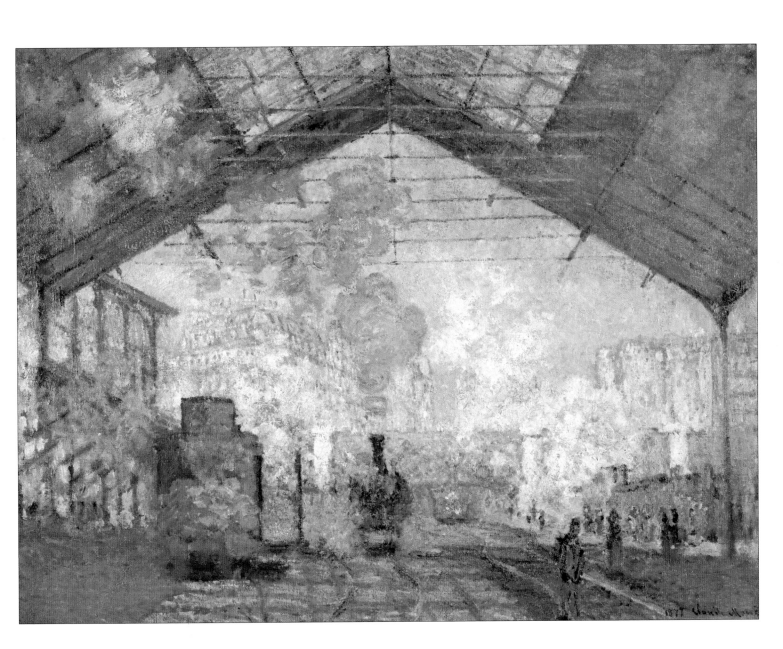

Plate 45

LA RUE MONTORGUEIL, PARIS

Oil on canvas. 1878. Musée d'Orsay, Paris, France. 80 x 50 cm.

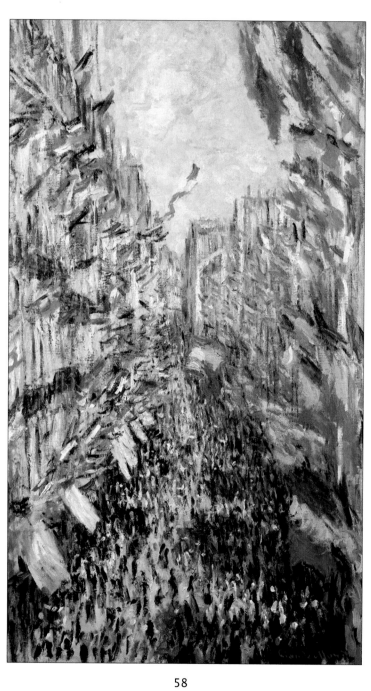

CAMILLE MONET ON HER DEATHBED

Plate 46

Oil on canvas. 1879. Musée d'Orsay, Paris, France.
90 x 68 cm.

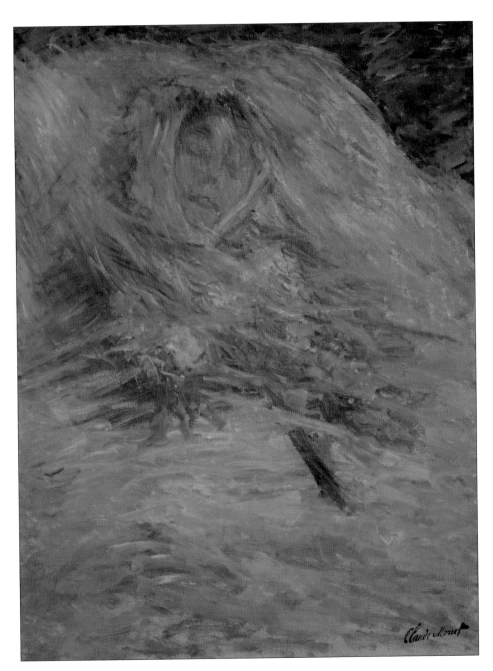

Plate 47

THE ARTIST'S GARDEN AT VÉTHEUIL

Oil on canvas. 1880. National Gallery of Art, Washington DC, USA.
151.5 x 121 cm.

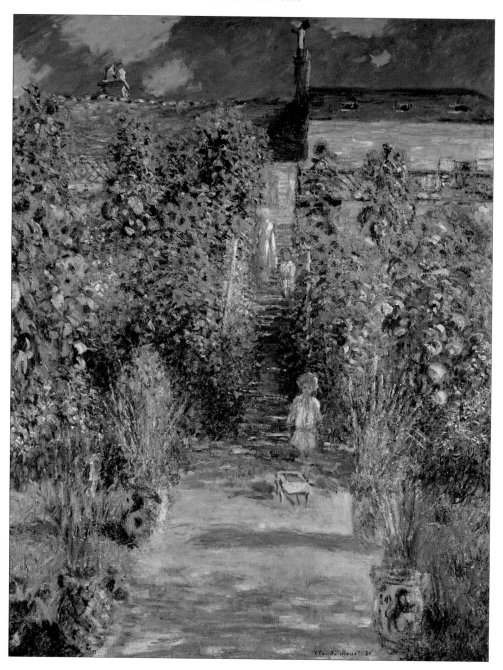

Plate 48

VÉTHEUIL

Oil on canvas. c.1880. Glasgow Art Gallery and Museum,
Kelvingrove, Glasgow, Scotland.
60 x 80 cm.

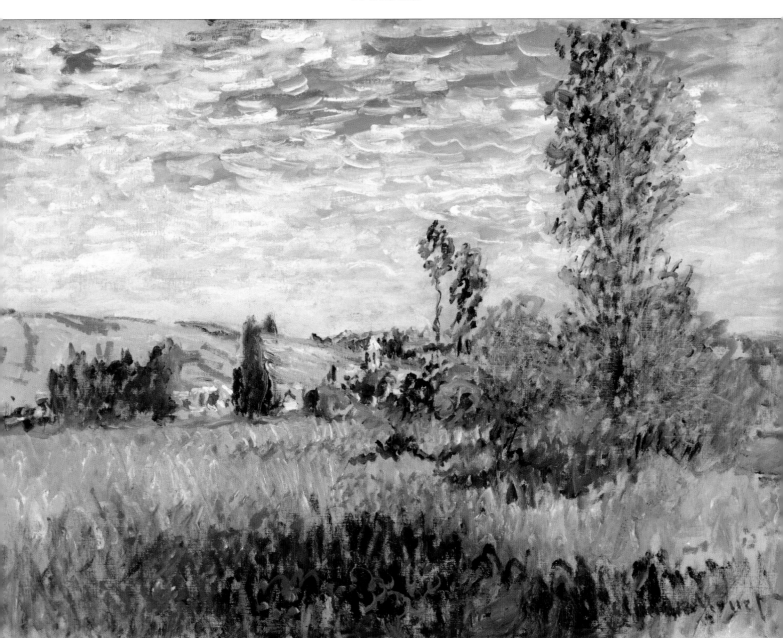

Plate 49 FISHERMAN'S COTTAGE ON THE CLIFFS AT VARENGEVILLE

Oil on canvas. 1882. Museum of Fine Arts, Boston, USA.
60.5 x 81.5 cm.

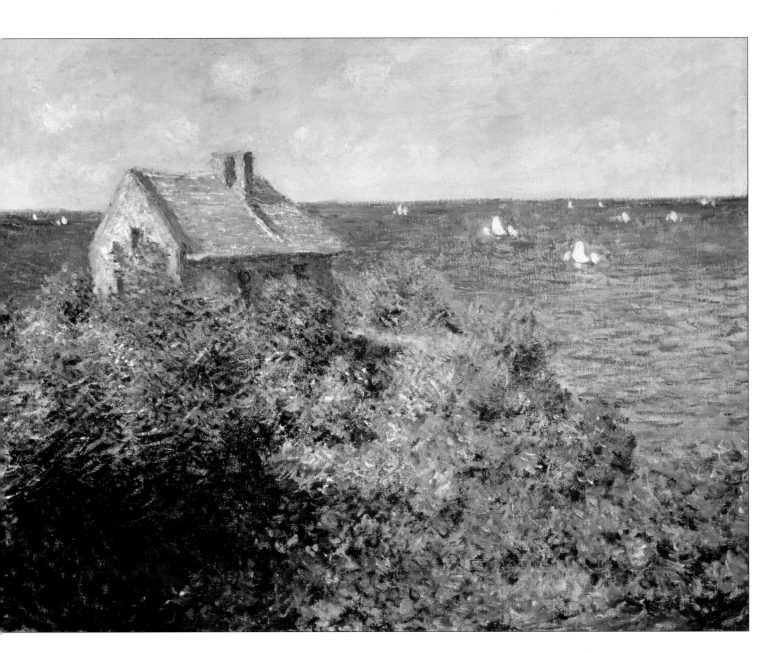

ROUGH SEA AT ETRETAT

Plate 50

Oil on canvas. 1883. Musée des Beaux-Arts, Lyon, France.
81 x 100 cm.

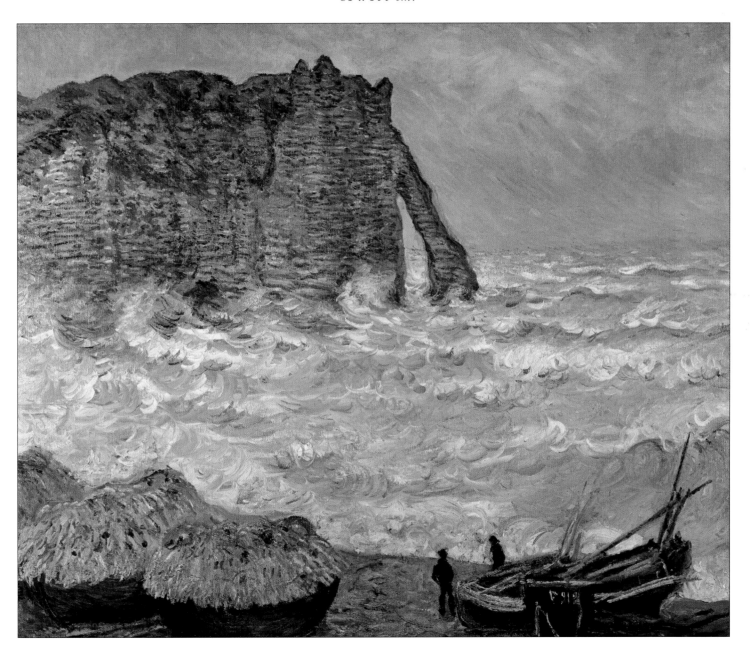

Plate 51

SELF PORTRAIT IN HIS ATELIER

Oil on canvas. c.1884. Musée Marmottan, Paris, France. 85 x 54 cm.

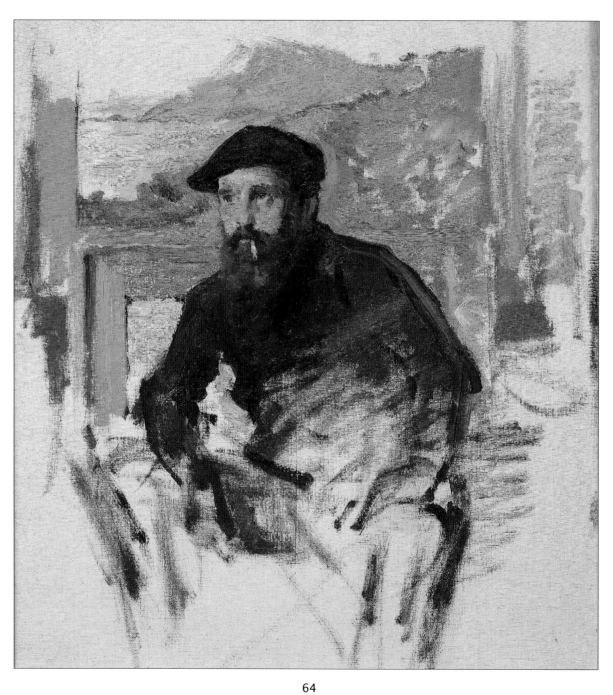

Plate 52

Oil on canvas. 1884. Art Institute of Chicago, IL, USA.
65 x 81 cm.

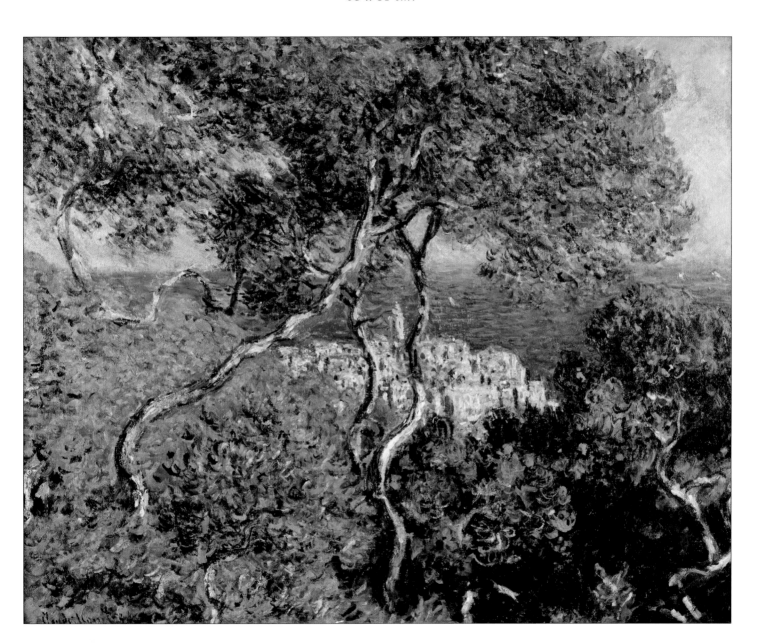

Plate *53*

STORM OFF THE COAST OF BELLE-ILE

Oil on canvas. 1886. Musée d'Orsay, Paris, France.
65 x 81.5 cm.

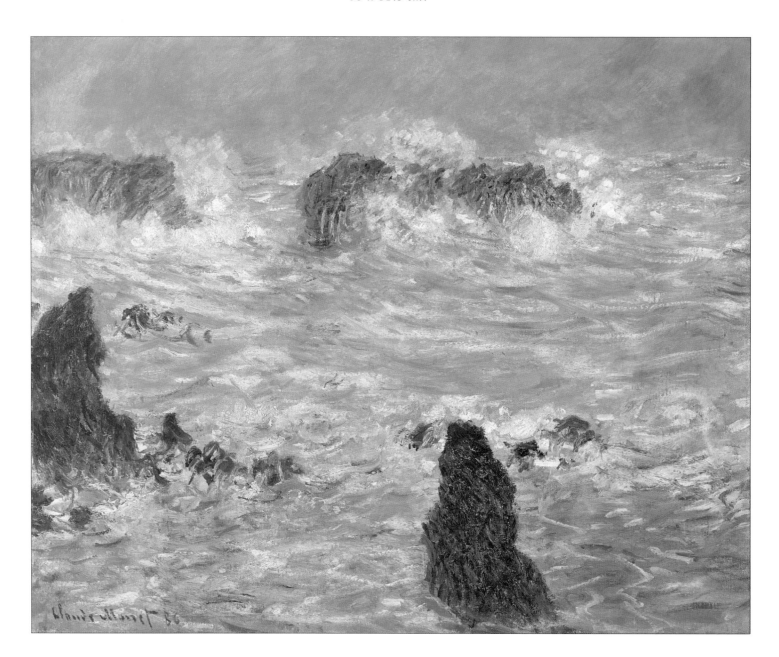

ROCKS AT PORT COTON, THE LION ROCK

Plate 54

Oil on canvas. 1886. Fitzwilliam Museum, University of Cambridge, UK.
65 x 81 cm.

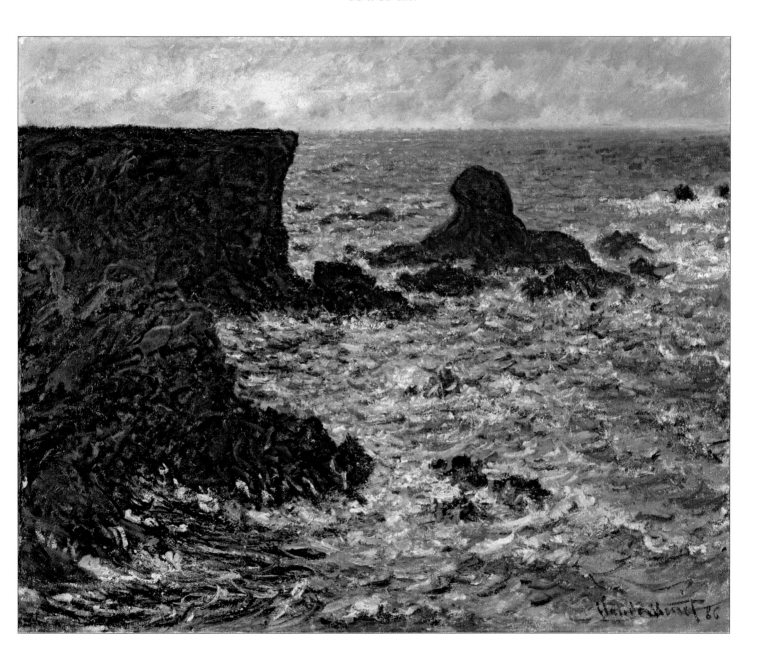

Plate 55

THE ROCKS AT BELLE-ILE

Oil on canvas. 1886. Pushkin Museum, Moscow, Russia.
66 x 82 cm.

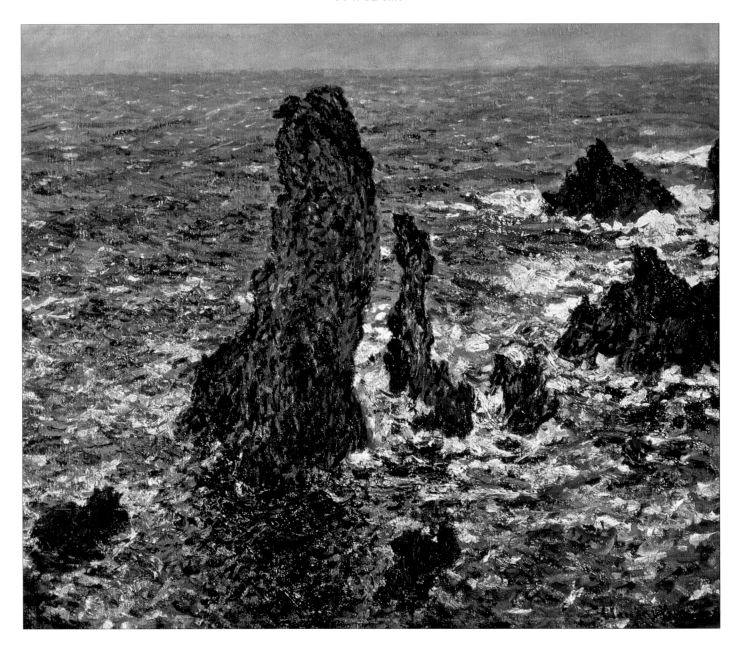

THE BOAT AT GIVERNY

Oil on canvas. c.1887. Musée d'Orsay, Paris, France.
98 x 131 cm.

Plate 56

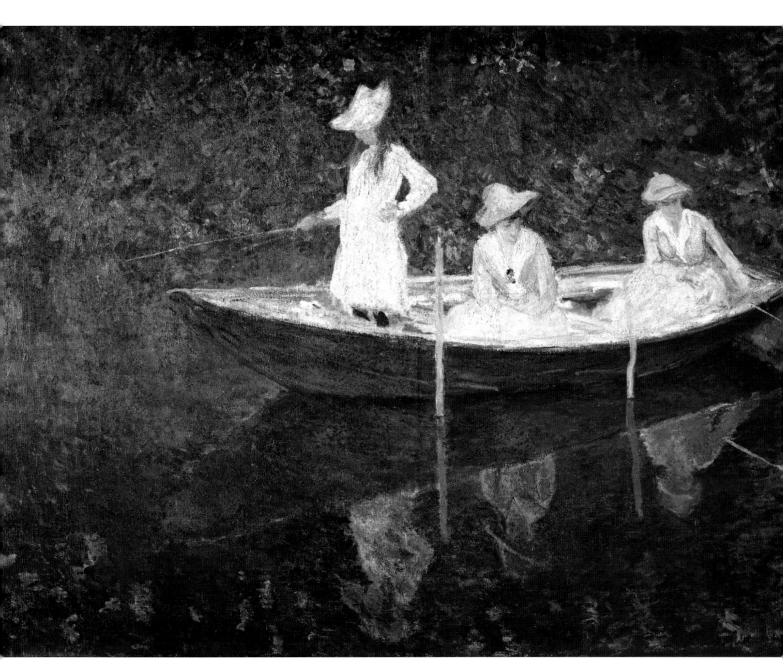

Plate 57

BOATING ON THE EPTE

Oil on canvas. c.1890. Museu de Arte, Sao Paulo, Brazil.
133 x 145 cm.

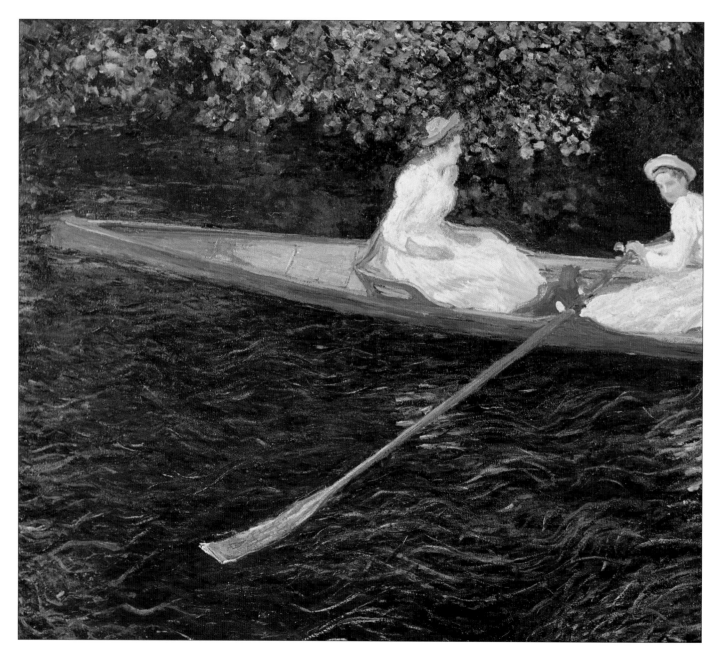

Plate 58

HAYSTACKS AT SUNSET, FROSTY WEATHER

Oil on canvas. 1891. Private collection.
66 x 93 cm.

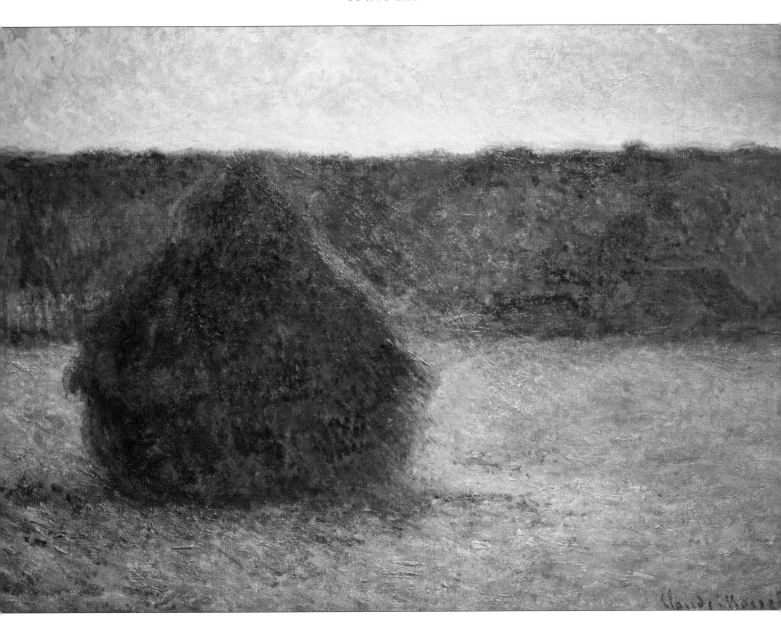

Plate 59 HAYSTACKS: SNOW EFFECT

Oil on canvas. 1891. National Gallery of Scotland, Edinburgh, Scotland.
66 x 93 cm.

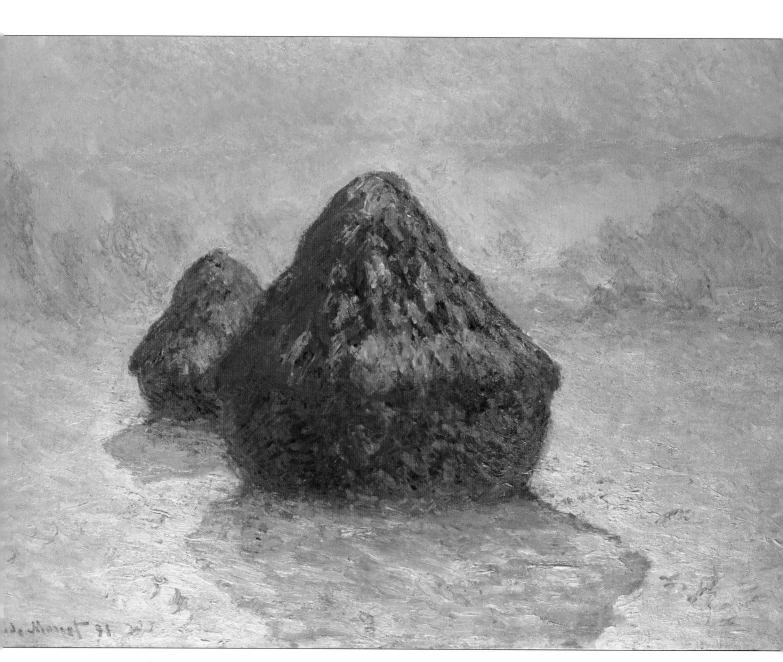

Plate 60

POPLARS ON THE EPTE

Oil on canvas. c.1891. National Gallery of Scotland, Edinburgh, Scotland.
82 x 81 cm.

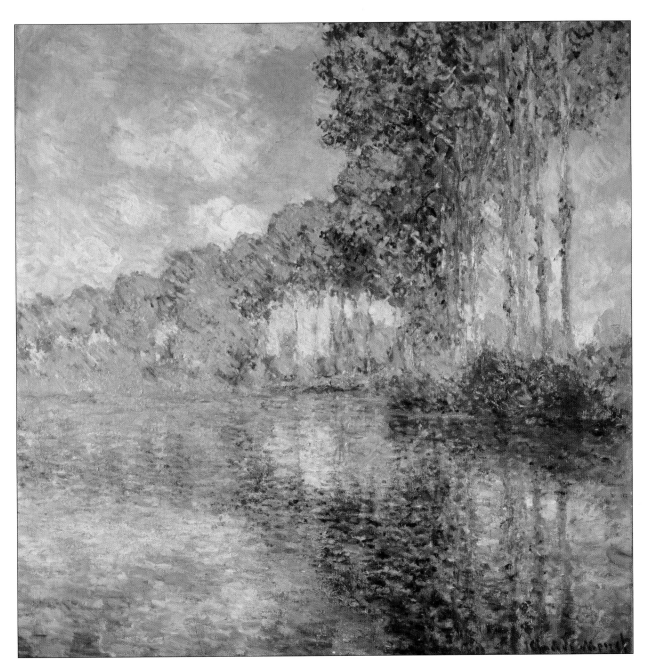

Plate 61

ROUEN CATHEDRAL, WEST FACADE, SUNLIGHT

Oil on canvas. 1894. National Gallery of Art, Washington DC, USA.
100 x 66 cm.

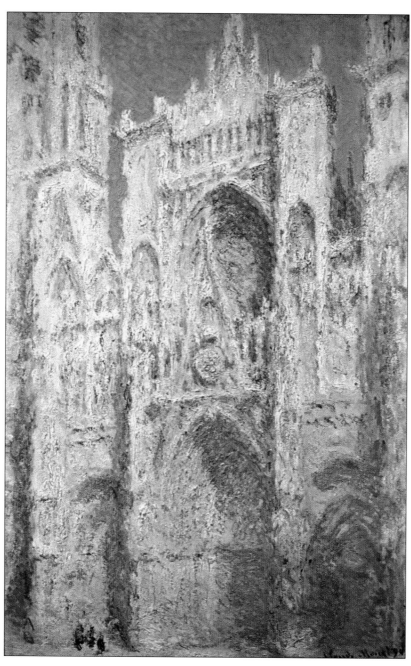

ROUEN CATHEDRAL IN THE SETTING SUN

Plate 62

Oil on canvas. 1892–94. National Museum and Gallery of Wales, Cardiff.
100 x 66 cm.

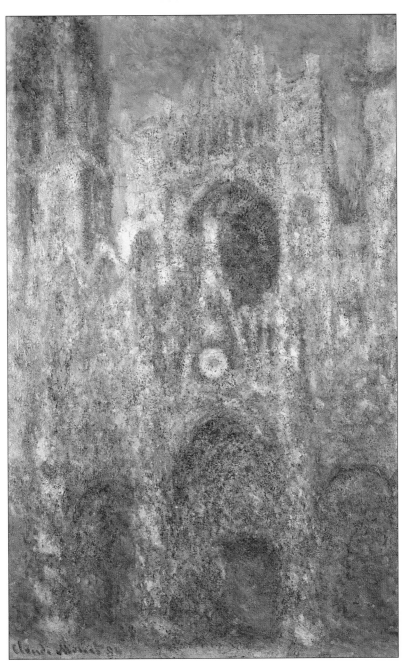

Plate 63

ROUEN CATHEDRAL IN FULL SUNLIGHT: HARMONY IN BLUE AND GOLD

Oil on canvas. 1894. Musée d'Orsay, Paris, France. 107 x 73 cm.

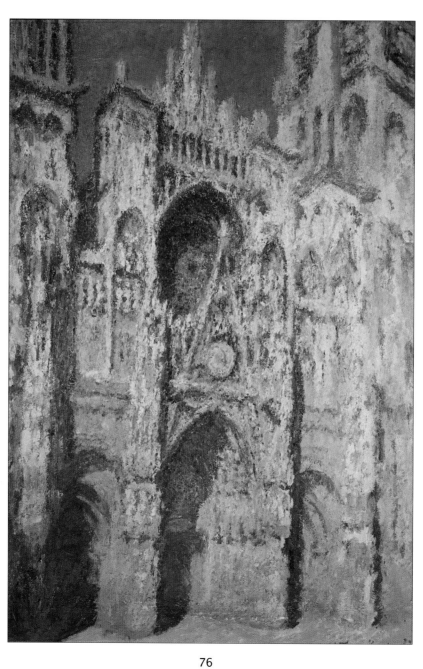

ROUEN CATHEDRAL FACADE AND TOUR D'ALBANE (MORNING EFFECT)

Oil on canvas. 1894. Musuem of Fine Arts, Boston, USA.
100 x 73 cm.

Plate 64

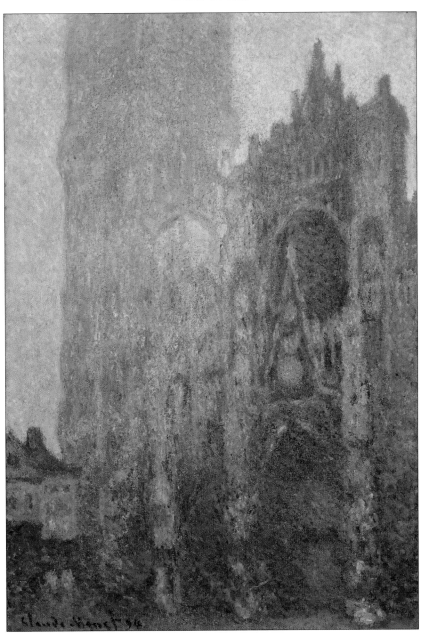

Plate 65

MORNING ON THE SEINE AT GIVERNY

Oil on canvas. 1893. Private collection.
90 x 93 cm.

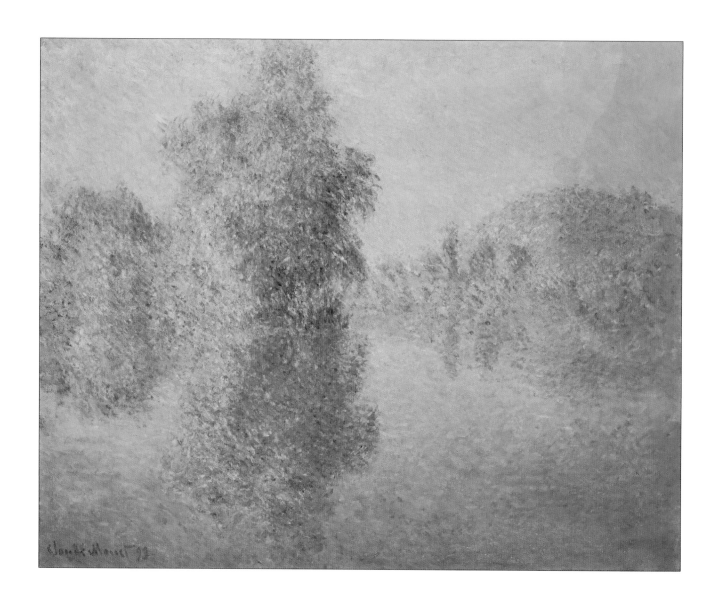

Oil on canvas. 1899. Pushkin Museum, Moscow, Russia. 89 x 93 cm.

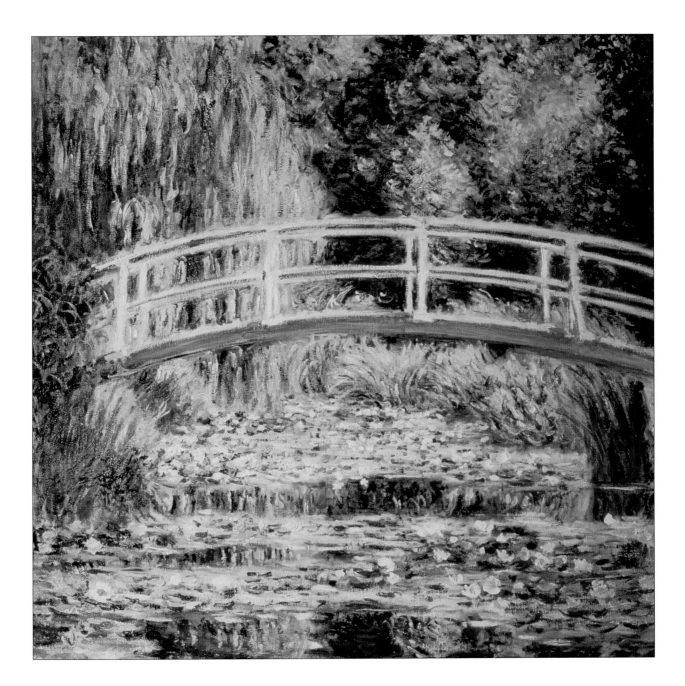

Plate 67

WATERLILY POND

Oil on canvas. 1899. National Gallery, London, UK.
90.5 x 90 cm.

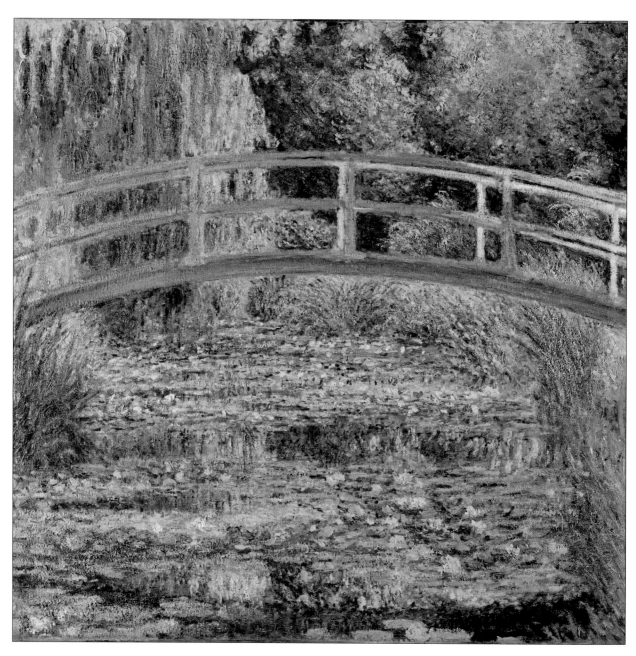

THE WATERLILY POND: GREEN HARMONY

Plate 68

Oil on canvas. 1899. Musée d'Orsay, Paris, France.
89 x 93.5 cm.

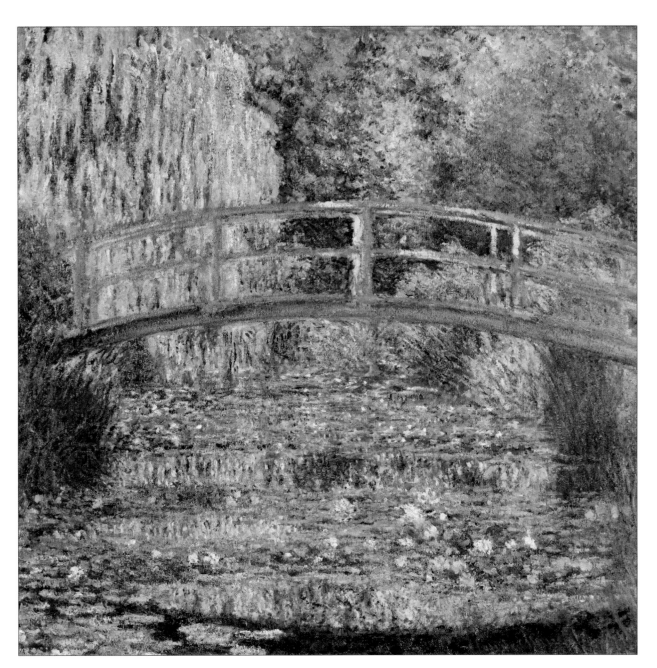

Plate 69

WATERLOO BRIDGE IN FOG

Oil on canvas. 1899–1901. Museum of Fine Arts, Moscow, Russia.
65.5 x 101 cm.

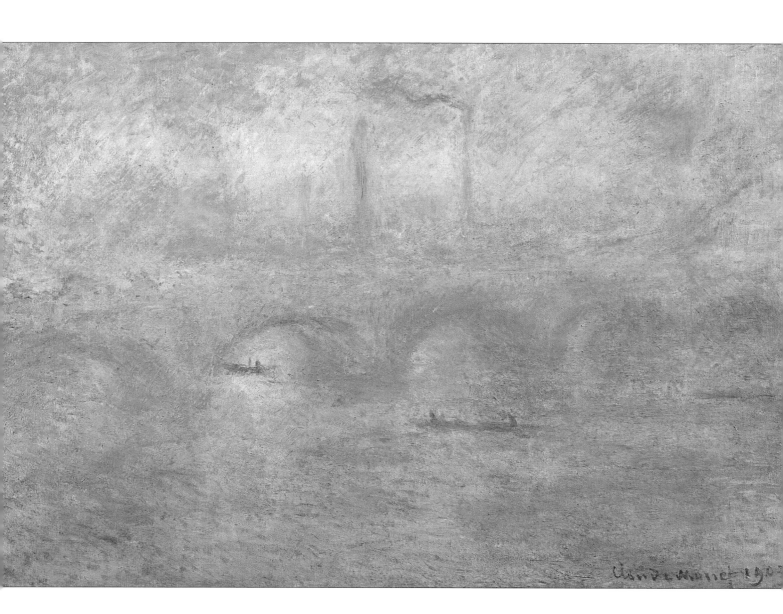

Plate 70

CHARING CROSS BRIDGE

Oil on canvas. 1899. Private collection.
65 x 81 cm.

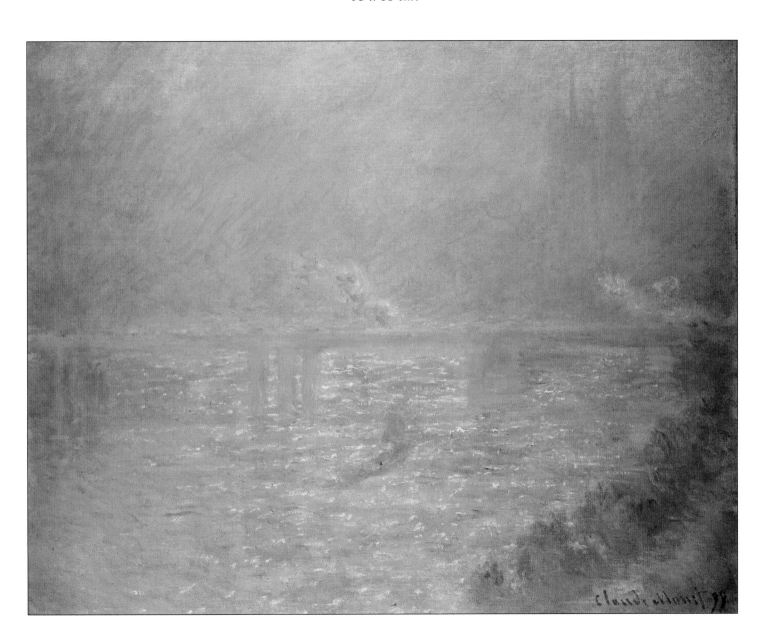

Plate 71

WATERLOO BRIDGE

Oil on canvas. 1902. Hamburger Kunsthalle, Hamburg, Germany.
65 x 100 cm.

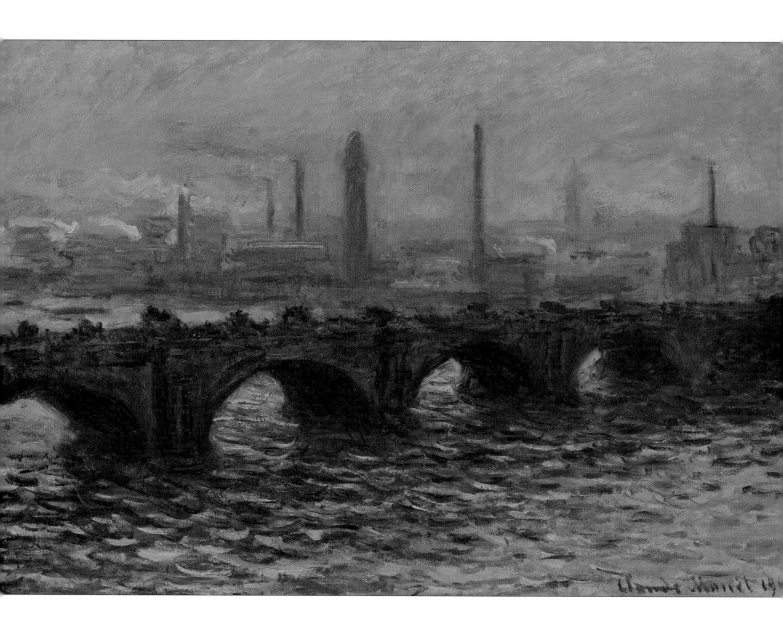

THE THAMES AT CHARING CROSS

Oil on canvas. 1903. Musée des Beaux-Arts, Lyon, France.
73 x 100 cm.

Plate 72

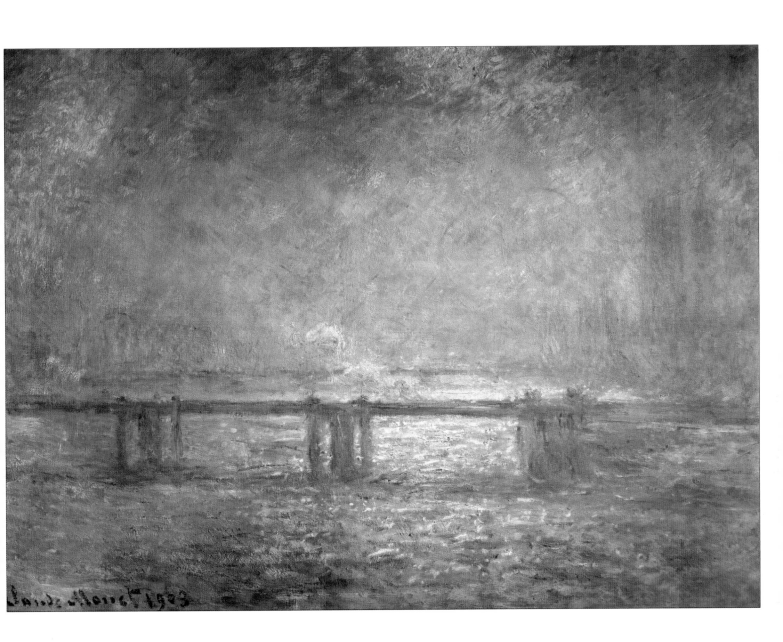

Plate 73

THE HOUSES OF PARLIAMENT, LONDON, WITH THE SUN BREAKING THROUGH THE FOG

Oil on canvas. 1904. Musée d'Orsay, Paris, France.
81 x 92 cm.

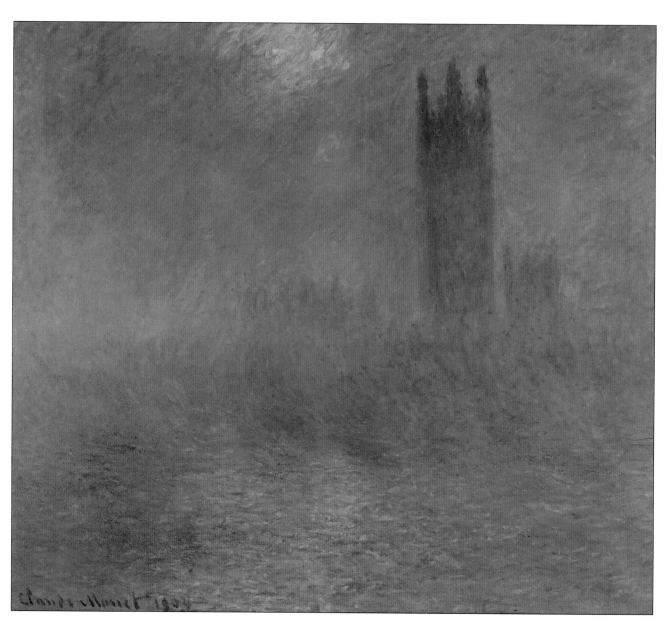

Oil on canvas. 1908. Musée des Beaux-Arts, Nantes, France.
81 x 55 cm.

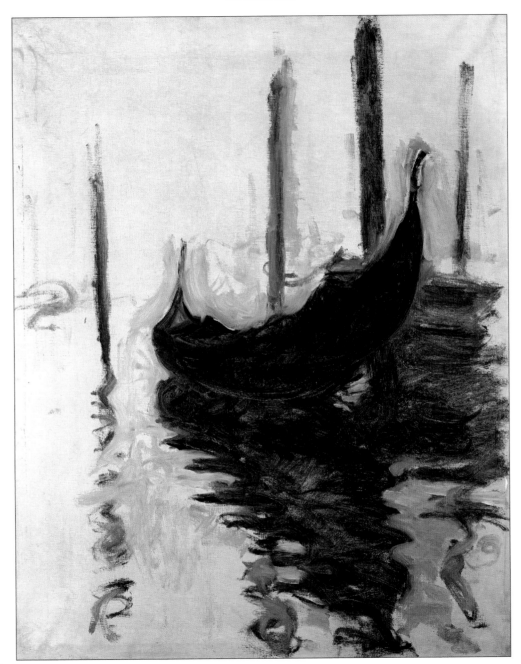

Plate 75

SELF PORTRAIT

Oil on canvas. 1917. Musée d'Orsay, Paris, France.
71 x 55 cm.

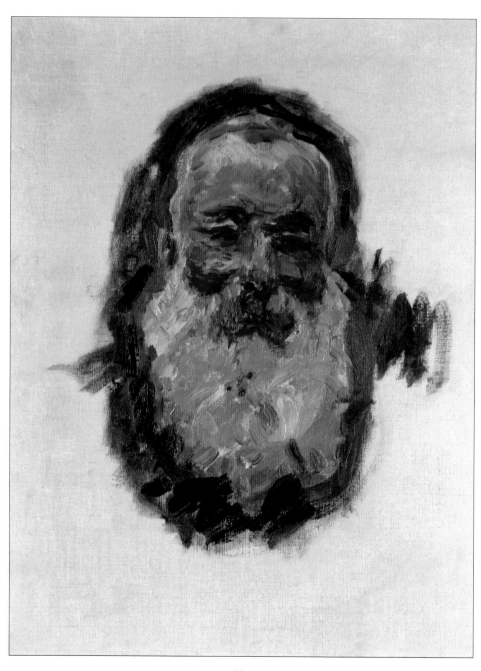

WATERLILIES

Plate 76

Oil on canvas. 1915. Musée Marmottan, Paris, France.
130 x 153 cm.

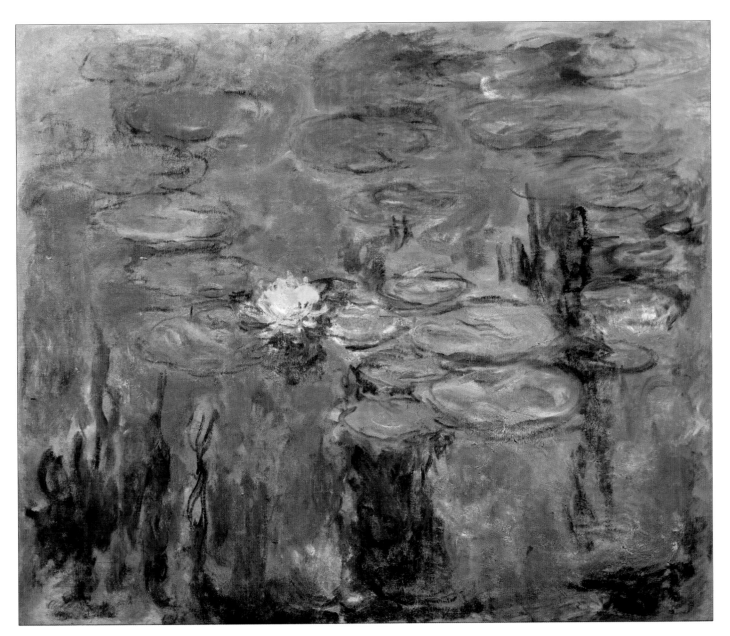

Plate 77

WATERLILIES AND AGAPANTHUS

Oil on canvas. 1914–17. Musée Marmottan, Paris, France. 140 x 120 cm.

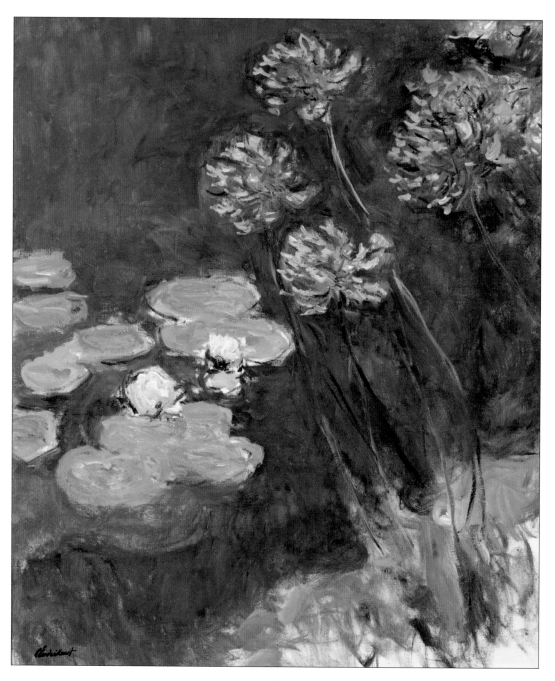

WATERLILIES AT GIVERNY

Plate 78

Oil on canvas. 1917. Musée des Beaux-Arts, Nantes, France.
100 x 200 cm.

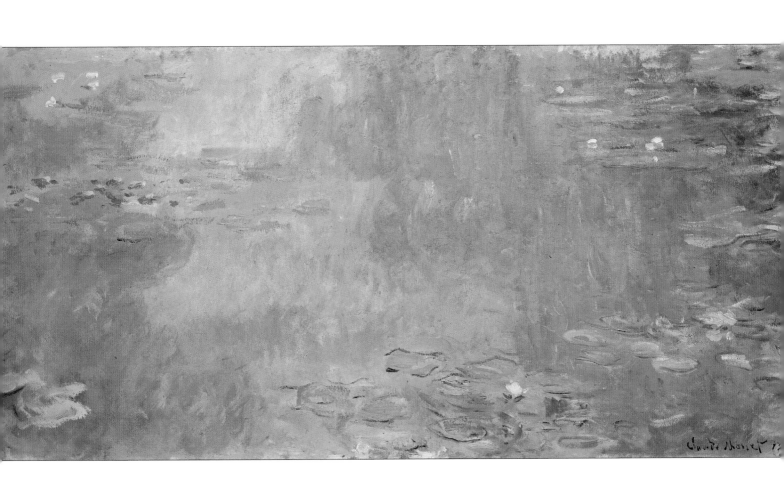

Plate 79

WATERLILIES: MORNING

Oil on canvas. c.1914–18. Musée de l'Orangerie, Paris, France.
Centre right section. 200 x 425 cm.

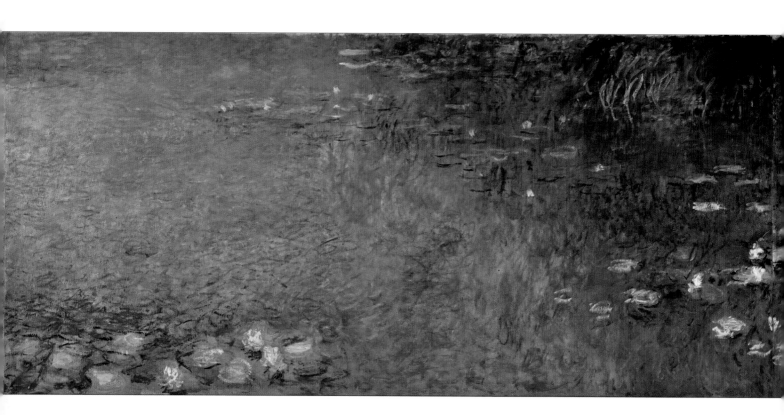

WATERLILIES: MORNING

Plate 80

Oil on canvas. 1914–18. Musée de l'Orangerie, Paris, France.
Right section. 200 x 200 cm.

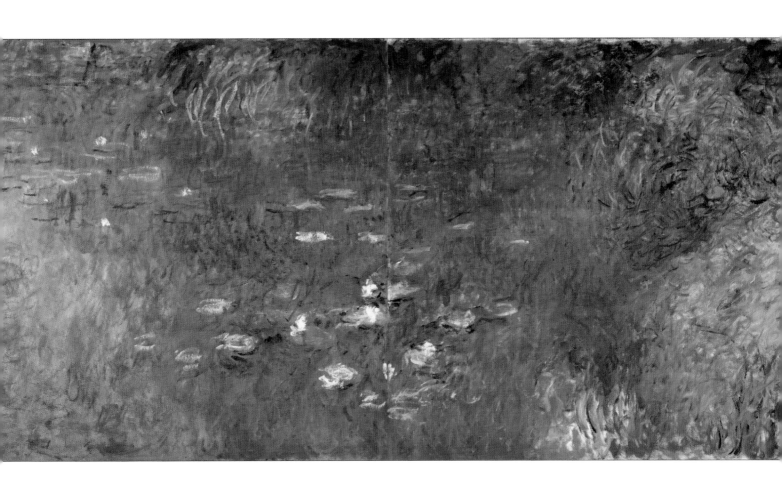

Plate 81

WISTERIA

Oil on canvas. 1920–25. Haags Gemeentemuseum, The Hague, The Netherlands.
150.5 x 200 cm.

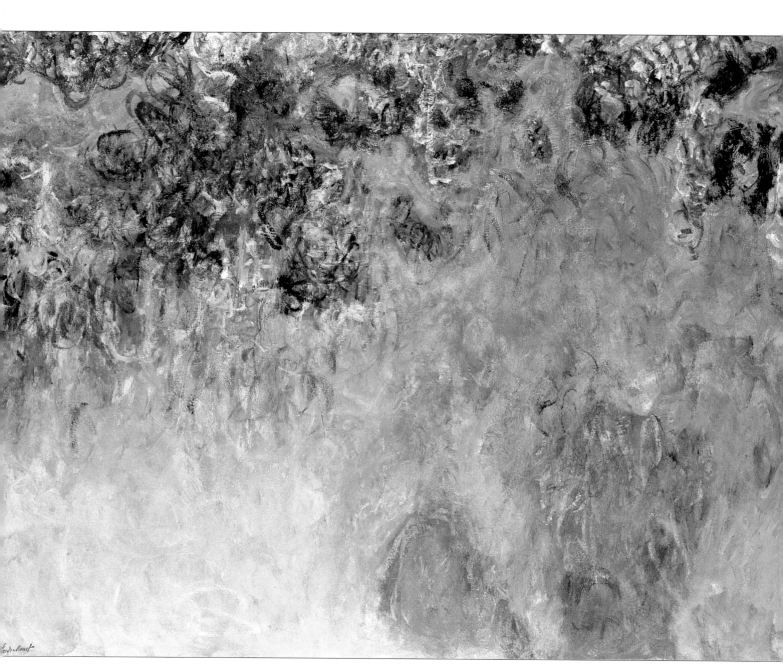

THE HOUSE SEEN FROM THE ROSE–GARDEN

Oil on canvas. 1922–24. Musée Marmottan, Paris, France.
89 x 100 cm.

Plate 82

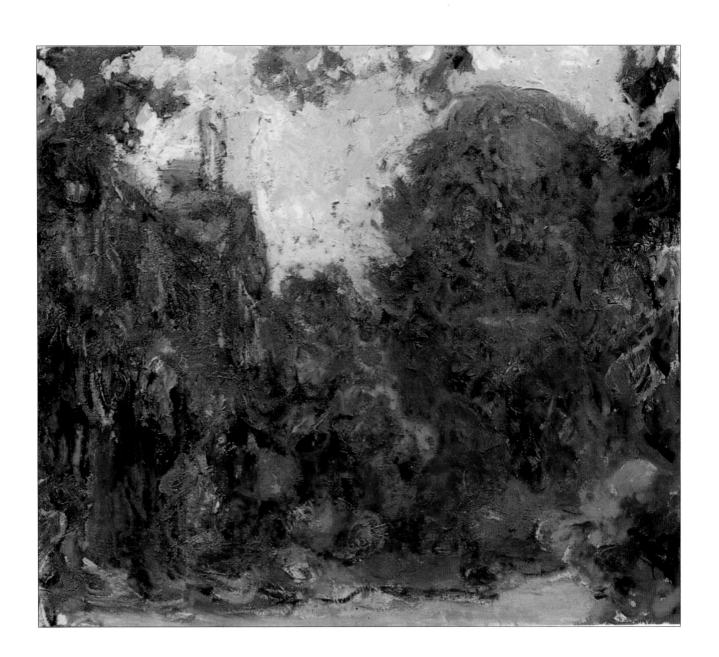

INDEX